Faceworld

Faceworld

—

The Face in the Twenty-First
Century

Marion Zilio

Translated by Robin Mackay

polity

First published in French as *Faceworld: Le visage au XXIe siècle.*
© Presses Universitaires de France/Humensis, *Faceworld*, 2018
This English edition © Polity Press, 2020

Polity Press
65 Bridge Street
Cambridge CB2 1UR, UK

Polity Press
101 Station Landing
Suite 300
Medford, MA 02155, USA

ISBN-13: 978-1-5095-3725-9
ISBN-13: 978-1-5095-3726-6-pb

A catalogue record for this book is available from the British Library.

Library of Congress Cataloging-in-Publication Data
Names: Zilio, Marion, author.
Title: Faceworld : the face in the twenty-first century / Marion Zilio ; translated by Robin Mackay.
Other titles: Faceworld. English
Description: Medford : Polity, 2020. | Includes bibliographical references and index. | Summary: "We have long accepted the face as the most natural and self-evident thing, as if the face were the public manifestation of our inner being. Nothing could be further from the truth. Rather than a window opening onto our inner nature, the face has always been a technical artefact-a construction that owes as much to artificiality as to our genetic inheritance. From the origins of humanity to the triumph of the selfie, Marion Zilio charts the history of the technical, economic, political, legal, and artistic fabrication of the face. Her account of this history culminates in a radical new interrogation of what is too often denounced as our contemporary narcissism. In fact, argues Zilio, the "narcissism" of the selfie may well reconnect us to the deepest sources of the human manufacture of faces-a reconnection that would also be a chance for us to come to terms with the non-human part of ourselves"-- Provided by publisher.
Identifiers: LCCN 2019030832 (print) | LCCN 2019030833 (ebook) | ISBN 9781509537259 (hardback) | ISBN 9781509537266 (paperback) | ISBN 9781509537273 (epub)
Subjects: LCSH: Face--Social aspects. | Face perception. | Facial expression.
Classification: LCC GN298 .Z5513 2020 (print) | LCC GN298 (ebook) | DDC 153.7/58--dc23
LC record available at https://lccn.loc.gov/2019030832
LC ebook record available at https://lccn.loc.gov/2019030833

Typeset in 11 on 13 pt Sabon by
Servis Filmsetting Ltd, Stockport, Cheshire
Printed and bound in the UK by CPI Group (UK) Ltd, Croydon

For further information on Polity, visit our website: politybooks.com

Contents

Contents

Acknowledgements

A small word but a huge thanks to Laurent de Sutter for his trust; to Lilya Aït Menguellet for her attentive reading of the text; to Matthieu Boucherit, Julie Cailler, and Julien Verhaeghe for their conversation and their presence; to Muriel Garcia for her absence.

1
After the Face

It was the night of the 86th Annual Academy Awards. The red carpet had been rolled out and anyone who was anyone was there, dressed up to the nines. But if the 2019 Oscars were a watershed moment, it was not because of the acclaim for *Twelve Years a Slave*, which garnered the first nomination for a black director, Steve McQueen; nor was it on account of the fabulous acceptance speech given by Jared Leto, looking remarkably like Jesus. No, that evening's ceremony was set to become a double record-breaker as the most liked and most shared image on the planet proceeded to break Twitter. 'We have made history,' proclaimed host Ellen DeGeneres, having received notification from the social network, while still live on air, that an outage had been caused by the runaway sharing of what has since been dubbed the 'selfie of the century'. In less than thirty minutes, the image had travelled around the world and across time zones and had been retweeted more than two million times, smashing the record previously held by a 2012 photograph of Barack Obama hugging his wife Michelle when he was re-elected. Although still pinned on the host's Twitter page, today the Oscars

image with its 3.4 million retweets already seems like old news. Three years after the event it was relegated to the ranks of former record holders by a certain Carter Wilkerson, a teenager who made a bet with his favourite restaurant chain in the hope of winning a year's supply of free chicken nuggets.

#NuggsForCarter overtook Degeneres's selfie – or should we say *usfie* – of a gaggle of stars, in which she appeared alongside Bradley Cooper, Meryl Streep, Julia Roberts, Brad Pitt, Angelina Jolie, Lupita Nyong'o, and Jennifer Lawrence. But what had seemed like a spontaneous whim on the part of the Oscars host was actually an impressive marketing coup orchestrated by Samsung – the evening's sponsor – to promote its Galaxy Note 3 smartphone. Making the stars into unwitting brand ambassadors, the South Korean manufacturer's VIP marketing strategy had converted their faces into exchange value, potentially revealing something more than just their own 'visibility capital'. Not that there was anything new in itself about the idea of using icons' faces as a sales pitch. Neither was there anything extraordinary, in a digital culture, about images being circulated, shared, and manipulated in all sorts of ways. And yet this act did herald a new turn, functioning as a kind of decisive *punctum* that would drive contemporary research on the selfie and determine its orientation.

The historic photo was taken on 2 March 2014 – just a few months before the word 'selfie' was officially added to the *Oxford English Dictionary*. Even though online self-portraiture had been silently proliferating for years, and even though various social networks revolved around images of users' faces, suddenly everyone was rushing to register their take on this new object. Who would denounce the narcissistic tendencies and egotistical neurosis of the individual? Who would see it as a

vast database capable of producing a sociology of the contemporary ethos, as in Lev Manovich's *SelfieCity* project?[1] Who would accuse it of being a profiling tool designed for advertisers or an aspect of the 'Facebookization' of the world? And finally, who would see this new face as a conversational object,[2] no longer the preserve of an oversized ego but open to others and to the world, in accordance with a relational logic typical of the so-called 'Web 2.0' era? Treated as pure data, quantifiable and analysable by way of a host of diagrams, curves, and algorithms, the face had become an insubstantial reflection of the contemporary aspirations courted by the industries of singularity.

But all that these proliferating discourses were really saying was that the portrait and the self-portrait genre no longer made much sense. The face was now operating in terms of avatars, profiles, traces, and indexes, apparently following a path opened up by the nineteenth century: that of a calculative reason, a limitless *ratio* that stripped the face of all its enigmatic qualities, converting it into a cipher only so as to decipher it with ever greater precision. Yet few commentators sought to trace these practices back to the processes that had originally generated them. And few paid any attention at all to a shift in terminology that had taken place unnoticed: no longer unique and private 'portraits', commemorative souvenirs of our forebears, but 'faces' – faces which had now become images, flows, commodities, screens for all kinds of phantasmatic, economic, and technical projections.

In response to this shift, during the twentieth century, art – which of course had been responsible for the first portraits – had instigated a programme of 'defacialization'. Everywhere faces were devoured, masked, erased, and reified. Artists sought progressively to obliterate the

categories of the 'subject', the 'self', and the 'I'; in other words, the category of identity in its most immutable, substantial, and metaphysical forms. This led to the creation of faceless faces, faces that were pure exteriority without interiority. No doubt the atrocities of war had left their black mark on the history of the contemporary face, as the themes of the ugly and the formless went hand in hand with the century of great wars. But the fact that the humanity of man could not survive the horror of the Shoah, and that this epiphany had brought him into conflict with his own stereotype, could actually be traced back to more complex antecedents. For the slippage from portrait to face and subsequently to the non-face actually responded to another crisis: the paradoxical crisis of the *invention* of the face.

This paradox is internal and unselfconscious: rooted in the most decisive features of the face, it operates in utmost secrecy. Whence this discrepancy: never in human history has the face been so widely represented and so firmly established; but at the same time, never has it seemed so threatened by emptiness and extinction. Affected by this obscure rift, the face seems at odds with itself; it seems to be consuming itself from within. Today the face may run a daily gauntlet of mirrors and multiple images of itself, it may circulate through networks and be shared by interconnected devices – indeed, all of this may have become more commonplace than ever before. But anyone who interrogates the origins of the face, and more precisely the possibility of individuals observing themselves, cannot deny that with the invention of the face, what we are dealing with is an event in the history of humanity that is relatively recent and, to say the very least, singular.

Chronicle of a Death Foretold?

With the Facebookization of the world, we have become so used to holding a book of faces in the palm of our hand that we no longer have any sense of the uneasiness of our ancestors, less than a century and a half ago, when for the first time they were able to pick up and hold their own externalized faces. Over a very short period, anyone and everyone would find themselves in possession of their face, materialized in an external medium. Thanks to photography, a portrait could be stored in a jacket pocket, passed from hand to hand, and transmitted from generation to generation. This democratization would be accompanied by an increasing uniformity and banalization of the face, to the point where some portraits could be switched in photographers' studios without the customer even noticing. The mass production and standardization of 'portraitomania' was accompanied by something close to a misrecognition of one's own face.

Although even today it is the lot of any person with restricted visual access to their face – limited to the traditional photographs of school classes, birthdays, and other such events – this deficiency in recognition has for the most part been superseded by a sort of hypermnesia: an infinite memory of self-images, where memory no longer designates the remembrance of the past or the outcome of a long-term crystallization, but instead a flashback, often to an anodyne moment, part of an everyday life constructed and broadcast in real time. Today the face of a foetus may be posted online even before birth. Plastic surgery can mould a face on demand, and science has made it possible to transplant a face – soon it will be a head – onto another body. Saudi Arabia has just granted citizenship to a silicon

face supposedly inhabited by an artificial intelligence, and the latest iPhone has made the face into a password. Who knows, in the near future we may file patents to assert our right to the uniqueness of our own face. We will no longer worry about surveillance cameras, but about applications that steal identities by manipulating expressions – like Face Swap Live, which allows Snapchat users to try on different faces in real time. By exchanging their own face directly and automatically with another, or with something else, this app allows its users to take on the features of an animal, an older person, someone of the opposite sex, a film star mask, or even a bicycle wheel. It's a feature that certainly lends itself to comic antics, but it is not difficult to imagine how it could be misused for criminal purposes. The promises of such effects are already tantalizing Hollywood studios quite prepared to spend millions of dollars on bringing back dead actors or rejuvenating ageing stars. We have begun to see the first attempts, in *Fast and Furious 7* and *Star Wars: The Force Awakens*, and in experiments by the research team who were able to make Vladimir Putin smile and Donald Trump say whatever they wanted him to. Since the face is exteriorized from the very outset, it is no doubt this potential for faces to be stored, modelled, and infinitely manipulated that explains digital natives' preference for applications that feature a pseudo-ephemeral temporality, where images are not captured but continually vanish into oblivion.

Facebook is a medium for people in their thirties, the medium of a generation that experienced the transition from analogue to digital, from the pre- to the post-Internet age with all of its personalized prostheses and their connected microphones and cameras. For ten years now it has served as a metaphor for the face's

new destiny – a face that is edited and published, eager to advertise and exhibit its intimacy. This everyday sociality may seem vulgar to our contemporaries, but in fact it lays the foundations for another reading of the face. The face may not just be a stimulus like any other, the metaphysical tradition may have seen it as the site of the encounter with the Other, and modern psychology may have postulated that it constitutes a primary form of interiority; but what has been forgotten is that individuals – that is to say, *indivisibles* – are only subjects in so far as they participate in a subjectivity that is shared, engaging with an exteriority that cannot be dismissed as merely secondary.

It is this exterior aspect, long consigned to the shadowy world of Platonic appearances or the depths of the unconscious, that constitutes the enigma of the face. Formerly the locus of an existential quest, in its contemporary form the face now seems more like a return of the repressed. The modern epoch exposed the face to its dark counterpart, reified and rendered banal by technical reproduction and exposure value. It became an inter-face, possessing the qualities of both interiority and exteriority, container and content, but also human and non-human. Modernity dreamt of a subject that observed, named, and possessed, but couldn't accept the fact that this subject itself would become the object of that same 'masterful panoptic egotism'.[3] Humankind's continuous observation of itself could not take place without inviting a third term into the equation: the technical milieu. What this revealed was the technogenetic dimension of the face – something which, in turn, would have repercussions for its ontogenesis.

We need only look back to see how, during the industrial epoch, photography's large-scale process of exteriorization of the face forged an *other* memory of

the face, one that was no longer biological but technical. While Gilles Deleuze and Félix Guattari warned that in any society what is essential is 'to mark and to be marked',[4] the invention of the face as a technical object made it just one product among others, a living archive available to all. Once only seen when they were depicted in genre paintings or revealed fleetingly in the reflections of stagnant waters or at the bottom of a cooking pot, just a few decades later faces would be everywhere, all of the time.

2
The Invention of
the Face

The face was probably the foremost obsession of the late nineteenth century. In summer 1839, before an audience drawn from all four corners of Europe, François Arago presented his invention, the daguerreotype, to the Académie des sciences et des beaux-arts, and would conspire to ensure a law was passed calling for his patent to be acquired by the French state, which subsequently presented it as a 'gift to the world'. If the potential of photography caused a public sensation, exciting as much enthusiasm and anticipation as the release of the latest iPhone does today, this was in no small part due to Arago's oratorical skills. As a good scientist and politician, he touted the scientific merits of his discovery and the tremendous prospects for progress it opened up. But, as Walter Benjamin observed, the ensuing public craze also owed to the unprecedented and even diabolical nature of his invention:

> To try to capture fleeting mirror images [...] is not just an impossible undertaking, as has been established after thorough German investigation; the very wish to do such a thing is blasphemous. Man is made in the image of God,

and God's image cannot be captured by any machine of human devising. The utmost the artist may venture, borne on the wings of divine inspiration, is to reproduce man's God-given features without the help of any machine, in the moment of highest dedication, at the higher bidding of his genius.[1]

Despite this prohibition weighing upon photography, it was widely hailed by the Parisian press and its success spread well beyond the borders of France. Endorsed by the social elite, it became a privileged subject of salon conversations and, thanks to its release into the public domain, was rapidly perfected. The volume and weight of the camera was reduced, the time it was necessary to pose became shorter, and the metal plate was replaced by glass negatives, allowing the making of copies. If technical reproduction necessarily dispossessed works and people of their 'aura', as Benjamin claimed, it was also accompanied by a dazzling 'technical halo' whose radiation would unconsciously permeate all strata of reality. Photography would become an industry that transformed the face of the world, and perhaps also the face itself.

At this time, the Western world was undergoing profound disruption. Electricity, railways, underground trains, the car, and the elevator, along with the telephone, the phonograph, the radio, photography, and cinema, all formed the backdrop for a technically apparelled [*appareillée*] society.[2] These innovations lay at the origin of a twofold paradigm shift: a rural exodus made it necessary to transform the appearance of the nascent metropolis, following the example of the boulevards envisioned by Haussmann, along with the possibility of recording and reproducing sounds and images of people. Modern democracies resulted from a

combination of the development of an optimized system of telecommunications and the deployment of a world of representations, a combination which reconfigured our relation to time and space, further intensified the telescoping of presence and absence, visible and invisible, real and fictional, and gave rise to new spaces of projection. A new world emerged, one of duplicates and of speed, of fluxes and fluidities, stalked by phantasmagoria, commodity fetishism, and the overflowing of nocturnal life into daylight hours. Affecting and transforming the sensibility of individuals, producing ever denser connections and industrializing the modes of production and reproduction of the visible, modern techniques revolutionized our ways of seeing, sensing, and inhabiting the world. According to a Marxian reading, this modern infrastructure reconfigured all of the ideas of society, its laws, its morals, its metaphysics, its language, and its political institutions. The senses, but also what makes sense – and yet more fundamentally, conceptions of the real and of the human – were all re-evaluated through the prism of technical mediations that now passed for immediate. This illusion of immediacy, reinforced by automation and rapid acceleration, led to the promotion of mobility and the present moment – which then meant it became necessary for flows to be archived, visualized, and stored, individual and collective memory preserved.

Not only did these techniques of reproduction transform knowledge and memory, they encouraged individuals to develop a taste for their own image. As Benjamin emphasized, 'The notion that one could be reproduced by the apparatus is an enormous attraction for today's humans.'[3] Baudelaire would develop this observation further, into a critique of modernity and, in short, of the bourgeois class. From this moment on, he

railed, 'our loathsome society rushed, like Narcissus, to contemplate its trivial image on the metallic plate'.[4] But above and beyond the narcissistic tendencies of his contemporaries, Baudelaire was concerned with denouncing the impact of 'the invasion of photography and the great industrial madness'[5] upon art and the imagination. The 'machinic turn of sensibility'[6] had begun. Culture would henceforth be the product of an industry that was bound to transform aesthetics and sensibility in general. With the rise of an individualizing society, it was ultimately the subterranean forms of a technical unconscious that were unleashed.

The face is an invention, for it responds to a programme – that is to say, an organizational plan that responds to rules established upstream of it. Mass produced and circulating within public space, the imagification of the face presented men and women with new scenes of representation which were accompanied by new forms of control. 'Visibility is a trap',[7] as Michel Foucault warned. From optical apparatuses to measuring instruments, from informal diagrams to disciplinary institutions, societies became enmeshed with an optical *dispositif*; and because it was at once that which offers itself to the gaze and that which properly belongs to a theory of vision, the face became both weapon and theatre of a war of visibilities. From this point on, the space of the circulation of gazes, that space where the play of face-to-face engagement between people takes place, would be formed of machinic interfaces and reflecting surfaces. During the nineteenth century, both the shop windows of department stores and the massive commercial production of mirrors exponentially multiplied the images of man. Just as painted portraits had long been reserved for the elite, so mirrors were considered by the people as precious objects of which one might

sometimes possess, at most, a fragment. These specular objects invaded bourgeois interiors, becoming a standard fixture in the bedchamber and then the bathroom by the beginning of the twentieth century. Eventually every corner of the home would be adorned by a face-become-image, the sensible apparition of a twice-present existence. From the peasant who, at the time, had little interest in his or her own reflection and saw it only on rare occasions at the hairdresser's or barber's, to the bourgeois concerned to use his portrait to maintain his social standing, all submitted to this new experience of the face.

For the first time in the history of humanity, everyone and anyone was able to see *themselves* and to *possess* a face – that is to say, to exchange it, pick it up, manipulate it, and capitalize upon it. This new memory of the face constituted a break in so far as, once reproduced by a camera, it became transmissible and accumulable. Like coins struck with the effigy of the sovereign, faces entered into an economy of flows. More than any other media, the specular function of photography and, later, cinema brought about a consciousness of individuality and of the collective. The masses would finally appear, 'brought face to face with themselves'[8] in close up and wide shot, acquiring an image that would represent them and confirm their political potency. In helping bring them to light, photography and the cinema contributed to the spectacularization of people and of the world, the creation of a spectacle whose starting point was man's continuous observation of himself, splitting him in two: into a *face-subject* and a *face-object*. The play of the face-to-face now involved not just human partners, but interfaces, cameras, markets, and quantified evaluations.

We have known since Foucault that the emergence of

the figure of man in the human sciences was dependent on certain fundamental dispositions of knowledge and that, if these latter were to disappear just as they once appeared, then 'one can certainly wager that man would be erased, like a face drawn in sand at the edge of the sea'.[9] According to Foucault, the human sciences were made possible by the disciplinary power to which they reciprocally offered an object, by describing the features of a human nature that could be objectively standardized. In this way, the epistemic basis of modernity introduced an imaginary wherein man was divided up according to various scientific sectors. With the advent of photography, this schema would take the form of an unprecedented visual *spatialization* and *temporalization* by means of a panoptic apparatus, an apparatus that claimed to 'see all' and to record all – including everything situated beyond and beneath human perception. Every historical formation inevitably forgets its own historicity and its controversies, and the history of the face is no exception to this rule. Just as Freudian anamnesis is understood as a work of forgetting that is essential to psychic development, the forgetting of the origins of the face serves to obscure its *traumatic* invention. The invention of the face as technical object established ways of being in the world, ways of thinking, and ethical norms whose institutional force is still with us today, albeit passed over in silence.

The Optical Unconscious: Seeing Flows, Coding Faces

Modernity was characterized by an iconographic programme for the inscription and revelation of the real, a programme that enrolled a great many scientists, doctors, and engineers, but also artists and intellectuals. As they saw it, in order to gain access to the real, one

had to set aside all suspect mediation by delegating to 'non-human'[10] instruments the task of translating and testifying to observed phenomena. This project for an 'auto-graphy' implied the idea of a government by experts, legitimated by invisible techniques, certifying the visibility and ordering of multiplicities. Photography was one such technique: it successfully escaped both the mediated nature of language and the illusory immediacy of the senses. It enabled the real to be expressed by translating indexically what the real communicated about itself, by itself. This prior objectivation was based on the idea of an organization of relations of forces that was based on the very form of the phenomena they produced – so the invention of the face by photography was more than an image or a portrait. It was a materialization of the face that would construct the category of the modern subject, just as it would determine the identity of the person it revealed. Here was an apparatus capable of assembling and directing a desire for subjection – that is to say, the desire to be a subject and to be subjected to the permanent control of this constructed identity.

As the world began to take on the form of a *continuum* of flows, the kinetic utopia of industrial modernity found it necessary to conquer time. Just as important as movement itself, if not more so, was the need to 'see' movement. It had to be fixed, or, even better, unfolded – like the flight of a bird whose movements, invisible to the naked eye, somehow had to be registered. Even before the birth of cinema, chronophotography, the invention of doctor and psychologist Étienne-Jules Marey toward the end of the nineteenth century, would make this reformulation of time possible.

Fascinated by the propagation of waves in a liquid medium, the circulation of blood, and the study of the locomotion of living organisms, Marey designed

numerous apparatuses for graphical transcription and 'sensible automata',[11] which were remarkable for their 'subjectless tact'.[12] The various flows examined by Marey were amplified, simplified, measured, schematized, synthesized – in short, reduced by the 'graphic method' to the essentiality of a trace, a proportional or statistical curve. Although these new images were soon to amaze and excite the imagination of his contemporaries, and while they may have heralded the promise of an absolute image of time, what they really produced were essentially metrical representations of living beings. And it was the figure of man, with his mastery of time, his control and calculation of its rhythms, that would now in turn be *discretized* and hence 'grammatized'.

Time would no longer be suffered passively; from this point on it would be controlled and optimized, as innumerable recording techniques allowed it to become the object of a procedural *ratio*. The transformation of continuous flows into *discrete units* – from blood coursing through the veins to a soldier's march – would fabricate rationally and graphically organized norms for individuals. Importing the model of the man-machine inherited from Descartes, Marey's epoch would renegotiate the definition of the living being from a biomechanical perspective, confirming Norbert Wiener's hypothesis that every epoch models the body in terms of the technology available to it.[13] In 1841, Johann Kaspar Lavater restored to common usage precepts of physiognomy that went back to Antiquity, describing it as 'the science or knowledge of the correspondence between the external and internal man, the visible superficies and the invisible contents'.[14] But unlike ancient and medieval epochs, modernity invented a natural physiognomy which, via an effect of analogy, claimed no longer to construct these signs, but to actually *reveal* them in reality. And

once again, it was photography that presented itself as the perfect instrument for such a definition. Photography did not just serve scientific discourse, legitimate it, or furnish proofs for it; since it *moulded* the gaze of a scientific community, and since it was impossible not to project a phantasmatic background into it, photography exerted its own agency as it assembled the shadow and light of the subjects whose traits it fixed.

In this way, the desire to record everything engendered a *revelation* no longer of flows, but of fluids of all kinds – of auras, of souls, of ectoplasm – in other words, of that which is most dissimulated or unconscious in the human. During this period, the instrumentalization of photographic media in the sciences and in the field of medicine, particularly in the study of mental illnesses, was justified by the hope of being able to see psychic and neurophysiological movements invisible to the naked eye. It was not by chance that the invention of photography was contemporary with the birth of both psychoanalysis and telepathy. Just like Edison's phonography, photography seemed potentially capable of revealing elements totally imperceptible to the eye and ear. 'For it is another nature which speaks to the camera rather than to the eye,'[15] as Benjamin remarks: the *optical unconscious* is discovered 'through photography [. . .] just as we discover the instinctual unconscious through psychoanalysis'.[16] Together photography and psychoanalysis exemplify the *schizz* of the subject, formalizing a face-subject and a face-object split along the lines of shadow and light, conscious and unconscious. The spiritual is transferred into the machine, investing it with a power that is now withdrawn from the human gaze. Passing through the machinic prism, nature is enriched with a *halo* that threatens the *aura*, but whose radiation doubles reality by spreading beyond it. Rather

than leading to the loss of the aura, as Benjamin suggested, technical reproduction led to the addition of a technical shadow that would reshape the ideological background of what is perceived. For such recording of the real was in fact only possible if phenomena were transformed into numerical values, if the irregular real became code.

Grammatization and Phenomenotechnical Synthesis

The work of Jean-Martin Charcot at Salpêtrière, whose iconographic oeuvre Georges Didi-Huberman discusses in depth in *Invention of Hysteria*,[17] confirms the slippages of a science unconsciously perturbed by its own techniques. The law of gender formalized by the French neurologist confirmed the extent to which much research was dominated not only by 'male' values, but also by a taste for scenography and artefacts. Assisted by the photographer Albert Londe, Charcot set out to 'grammatize' the nosological criteria of the hysterical woman through the use of a range of startling techniques, from hypnosis to 'staging'. This manner of *defining* and *reproducing* gestures, as well as rictuses and facial expressions, echoes what Sylvain Auroux and Bernard Stiegler, following Didi-Huberman, designate by the term 'grammatization'. Understood as the process by which the flows and continuities that make up existences are *discretized*, grammatization is a conversion of movement into discrete units that allow for the exhibiting, unfolding, and unpacking of the face into as many facial typologies as there are categories. Writing, as discretization of the flow of speech, designated one stage of grammatization; photography, as technique of visual storage, incarnated another.

Charcot's genius, then, was to establish a description

calibrated to a general type and taking the form of a synoptic table. The observations of any given 'case' would now be related to 'a visible *alphabet* of the body'.[18] This unpacking of the face orchestrated by scientists directly and automatically exteriorized it into traces, curves, and segments. Even more than legal institutions, it was laboratories that set the stage for a technical requalification of identity which, by relating it to criteria of measurability, would change its nature and that of the subject to which it applied. If, fundamentally, every technical revolution transforms the subject of knowledge, it also transforms the processes by which being gives itself to be seen. The problem of phenomenological apprehension thus becomes that of *phenomenotechnical production*. As Gaston Bachelard insists, as soon as we move from observation to experimentation, 'phenomena must be selected, filtered, purified, shaped by instruments; indeed, it may well be the instruments that produce the phenomenon in the first place'.[19] Introducing the concept of 'phenomenotechnics',[20] Bachelard showed how, by means of its instruments, science *constructs* new dispositions of knowledge, which *learn from what it produces*. Science can know only what its array of technical apparel [*son appareillage*] allows it to see. When they made use of photography, neuroscience and psychoanalysis understood themselves to be perceiving unconscious or imperceptible phenomena – phenomena that were not phenomena. Consequently, these techniques *discovered* their a posteriori nosological categories by means of what they had *constructed* a priori – resulting in phenomena that 'bear the stamp of theory throughout'.[21]

The conversion of our profiles into data which are then subjected to data mining seems subject to the same principle of phenomenotechnical construction.

Organizing these swarms of data by means of algorithms, statistics, or artificial intelligence is a matter not of simply describing phenomena as if they pre-existed the theory that thinks them, but of constructing them by means of the technical systems that make them appear and the developers who code those systems. In this sense, a 'measuring instrument always ends up as a theory',[22] and consequently the microscope, photography, and today's algorithms must 'be understood as extending the mind rather than the eye'.[23] The modern tendency to try to capture the invisible and to tame it with whatever images the technology of the day can make of it is a basic tendency that has always been present. Where Charcot's era hoped to visualize the depths of the soul through 'irrefutable proofs', it would seem that we proceed similarly today with a technical vocabulary whose embedded ideology we no longer perceive.

Understood in this way, the face cannot possibly correspond to the 'Infinite' as defined by Levinas – that site or lofty height at which all the possibilities of transcendence come together, and from which the ethical imperative proceeds.[24] Nor can it be the guarantor of an 'ultimate retrenchment',[25] the possibility of a last refuge faced with the process of banalization to which photography subjects it. The face is no longer the starting point of an ethics but the endpoint of an experimental programme that has constructed it. Photography is a machine for making truths that draws its authority from its indexical power, from an automatized, acephalic functioning, while it wields over consciousnesses the power to capture not only memories but imaginaries and beliefs as well. Thus the cold and mechanical writing of photography opened up empty spaces, and there was a slide from positivism into an idealizing objectivism in which vision is fabricated as spectacle, and phantasmagoria creeps

in. Individuals became the objects of a 'fictionalization' formulated in laboratories, a fictionalization that came into effect as soon as the real had been doubled and coded. Rather than an object of study, the individual became the object of a scientific gaze augmented by a medium whose neutrality had no manifesto other than its name. This is why the face results first of all from a *technogenesis* – that is to say, from an evolution of technics which is, circularly, constitutive of an *ontogenesis*, and in turn models a technical imaginary. In his 1958 *On the Mode of Existence of Technical Objects*, Gilbert Simondon emphasized the need for an accompanying fiction that would clarify and complement technicity. If technics moved from being an object of discourse to being a discourse of the object, the face itself became the object of technological *narratives* enframing and legitimating the invention of this same technics. Similarly, the conversion of our faces into digital profiles today echoes the technical and marketing discourses around Big Data. So that it is no longer the object, in this case the face, that is intriguing, but the fictive and ideological matrix that surrounds it.

The Face as Diagram

While Charcot and Duchenne de Boulogne strove to establish an orthography and a grammar of the face for the use of both scientists and artists,[26] the anthropometric method perfected by criminologist Alphonse Bertillon in 1880 combined a precise photographic protocol with measurements meticulously collected using dividers, rulers, and grids. Born into a family of statisticians, the young officer, a notorious anti-Semite, saw the different parts of the head as modules that could be arrayed into the cells of a table, just like the cells of Jeremy Bentham's

panoptic architecture. Each fragment of the face – ear, mouth, nose, etc. – was reduced to a discrete unit: that is to say, spatialized. These tokenized portraits, simplified to their signifying surface alone, thus begin to seem more like a kind of map or diagram – an impression reinforced by the orthogonal grids that appear in some of the photographs. If Ptolemy had used the body to think geography, now maps were being used to define and control the body and identity. The fundamental process presiding over the development of these facial units was based on a principle of the 'spatialization of information', just as writing had been. The map made these discretizations into a kind of visual lexicon, prescribing a metric, a scale, and a substance. Calibrated, packaged up, the face was reduced to a *facies* assigned as synthetic liaison between universal and singular; it was assigned to the regime of representation.

In his discussion of the passage from orality to writing, Jack Goody emphasizes the extent to which the development of the written trace involved the use of graphic conceptual devices such as lists, tables, inventories, registers, and collections. Goody understands writing as a 'locational sorting device'[27] that allows the establishing of a 'visual storage'[28] conducive to the emergence of what he calls 'graphical reason'. Although it may have fuelled the fears evoked by Plato in his *Phaedrus* – namely, that the exteriorization of memory leads to a loss of knowledge – the transferring of thought onto an external support also opened up a great many new configurations for the brain. Among other things, writing allows a more effective checking of facts thanks to the possibility of comparing, judging, and contrasting ideas from archived documents. As writing became the instrument of a new intelligence, it deeply transformed the situation of knowledge, its symbolic and ideological

promulgation, and relations between individuals and the administration of society.

Just like writing, photography in its turn transformed continuous flows into 'visual storage'. But while objectivity redoubled by the photographic protocol proved to be a powerful operator for thought, its implacable mechanism also turned out to be an apparatus for the dissection of the world, for the despotic ordering and division of classes and identities. The simplification of forms according to graphical, geometrical, or stereotyped models – just like the flattening of the depth of the real in favour of a two-dimensional vision – assembled new fields of action and thought. The translation of the face into numerical data to be catalogued and indexed gave rise to a *diagrammatic* vision, at once descriptive and statistical.

In Foucault, the notion of the diagram issues from the disciplinary model of modern societies, in which power operates a partitioning and control of the entire social field by applying itself not only to the visible, but also to all articulable functions. Consequently, the diagram is like a 'map of the relations between forces' which 'take place [. . .] within the very tissue of the assemblages they produce'.[29] It is informal in so far as it knows nothing of the division between the visible and the articulable, and yet it is the presupposed immanent cause of this division. It is 'a machine that is almost blind and mute, even though it makes others see and speak',[30] as Deleuze says in his book on Foucault. This *optimum* revealed by machines and laboratory tests evaluates an observation and converts it into a diagrammatic image, which in turn translates into a discursive formation. Prior objectivation determines a field of potential action that is apparently 'independent of all human will',[31] like that sought by Saint-Simon in 1820. During this period, a

veritable process of graphology, or even autography, was being set in motion, the idea being that a 'moving body could itself be made to trace its path in the form of a curve'.[32] Become an object of knowledge, the face tended toward technical reification and, consequently, submitted to a permanent control. This is why Deleuze adds: 'No doubt power, if we consider it in the abstract, neither sees nor speaks. [. . .] But precisely because it does not itself speak and see, it *makes us see and speak*.'[33] *To make the face speak* means, in the final analysis, that the relations of force take place 'not above', but within the very tissue of the assemblages they produce. The problem is not the essence of rationalism, but the fact that it becomes engulfed by an idealizing objectivism.

The Proletarianization of the Face

The transferring of the figure of man onto external memory supports gave rise to a collective experience that was problematic from the very start. On the one hand, it awoke desires for the extension of the person, desires which, following the model of private property, manifested themselves in terms of the material extension of the self. On the other hand, it brought with it a new management of these mobile identities based upon metric protocols. It was quantification, along with spatialization, that wove the fabric upon which the flows would circulate.

To eliminate human subjectivity in favour of an acephalic technology was the unavowed project of modern politics, and this reduction of the human to the calculable responded to a well-known economic conjuncture. The spread of democracy had led to an 'increase in the *floating* population',[34] the primary issue being how to *fix* and regulate this flow. The other aspect of the

conjuncture consisted in the acceleration of the means of production, the profitability of which had to be increased. Everything at work within modern societies, in the political, cultural, and psychological domains as in the domain of ideas, had to respond to a primary movement: that of the economy. In fact, the scientific applications of the geometric method developed by Marey would rapidly be placed in the service of the iconography of the industrial world. His studies on walking, breathing, the economy of muscular forces, the gestures of athletes, workers, and so on, inspired certain proponents of Taylorism such as Jules Amar, the couple Frank and Lilian Gilbreth, and even Charles Frémont,[35] who did their best to go beyond the pure research presented by Marey and to develop its discretizing potential into a model for management, distribution, and optimization. The biopolitics in question here accompanied the passage from ontological abstraction – where the face was decoupled from its carnal envelope and reduced to calculations – to industrial instrumentalization, where it would become a productive body, a face that speaks and makes speak.

The grammatization of the face would lead to its proletarianization, in Bernard Stiegler's sense. Stiegler states that the proletariat 'is constituted not by the working class or labour in general, but by the exteriorization of knowledge with respect to the "knower"'.[36] Grammatization discretized the gestures of producers with a view to their automated reproduction. In other words, proletarianization proceeded from a loss of participation, which was also a loss of knowhow and of knowing how to live. Proletarians were disindividuated, as a short-circuit removed them from the process of individuation via which they became what they were. In this respect, paradoxically, the problem of proletarianization

also affected the figure of the bourgeois, whose quest for the extension of self had attained its point of paroxysm with the 'portrait cards' introduced by André Adolphe Eugène Disdéri. By creating a room equipped with four or six lenses that allowed multiple negatives to be taken on one plate, Disdéri circumvented two constraints: cost and the length of time required for posing. Cut and mounted onto a cardboard backing, the *carte de visite* format was particularly suitable for passing from hand to hand and exchanging in a social context. It democratized and popularized a genre, which took on a character more informational and communicational than commemorative, in step with the short-termist media regime of the popular press. The face of the people would now be 'contemporized' – that is to say, made *by* and *for* contemporaries.

Portraitomania was determined by a set of codes, aesthetic norms, and practices that together established an *impersonality* that served to create bonds between people. As Louis Quéré emphasized, impersonality was the 'correlate of an apparatus of socialization that links individuals only by excluding their personality and their subjectivity from social visibility'.[37] Against all expectations, through the massive industrialization and commercialization of its photographic portrait, the bourgeois visage became as anonymous as it was anodyne, and hence now seemed utterly incapable of singularizing itself.

The word 'visage' invites us to reconsider the intrinsic relation between *seeing* and *saying*. Stemming from the Latin *vis, videre*, meaning 'faculty of seeing', the visage is associated with 'aspect' and 'appearance'; it is the external part that one offers up to be seen, from which *one constructs* the aspect. But it is also synonymous with 'face', which has the same root as the French *faire*, to do

The Invention of the Face

or to make. The face, then, is *what one makes in order to offer (oneself) to be seen.* Now, what we see in portrait cards is an ideal of integration into certain common criteria defined in the highest echelons of society. The desire for uniformity, the desire to conform to a standard social model according to a precise arrangement – fixed poses, seated or upright, armed with specific attributes and décor – saw social stature calibrated according to aesthetic posture. The bourgeois face constituted itself by way of preselected signs. Become a serialized entity, a standard product, both multiple and identical, it was no longer a question of singularity, but instead of particularity. Proletarianized – that is to say, deprived of the knowhow by which the individual acquires a face that is singular and can be made 'one's own' – the portrait card produced a fixed, preconstituted identity, not a self-constituting one. The identity of the bourgeois face, trapped by its norms, reduced to a particularism, became a reproducible and interchangeable datum, like a worker on a chain gang.

The bourgeois face was revealed through the use of cosmetic technics – that is to say, technics of appearance: the mirrors that lined the walls of bourgeois properties, or the everyday use of visiting cards. In allowing the bourgeois to see *themselves*, to realize *themselves* through their own judgement, such mediations 'liberated' them from the other's gaze, formerly the sole legislator. The image of the bourgeois would extend beyond his or her own sphere of proximity but, taken up in the circulation of signs that any cultural exchange implies, it would also bow to the technical and iconic specificities of its mode of presentation, at the risk of losing all singularity.

Now, what is paradoxical in this process is that, even while seeing himself in relation to universalizing

27

examples, modern man undeniably tended to *retrench* himself by way of nationalist, corporatist, racist, or paternalist reterritorializations. During this period, the self-portrait and biography were both fashionable genres. Everything gravitated around the intimate, the *self*, introspection, the notions of 'ego', 'consciousness', and self-feeling [*sentiment de soi*]; more exactly, everything was structured around the notion of *private property*. Privatization, along with industrial modes of production, favoured exclusion and standardization, tendencies that were amplified by the photographic apparatus. So that the technical imaginary of the face was at once *compartmentalized* – each face in its correct cell: the worker, the bourgeois, the hysteric; *Taylorized* – since the production of faces responded to principles of standardization and surveillance; and *binarized* – one *or* the other, rich *or* poor, man *or* woman.

The grammatization of the visible, which began with a set of techniques for the discretization of movement – that is to say, for the decomposition of flows – converged with the process through which the first faces had emerged. From the time of its first 'imagification' via photography, then, the face presented itself as a *materialized retention*. Not that it was a pure invention of the nineteenth century, but this period democratized a genre – the portrait – that had formerly been reserved for the elite. What is more, with photography it acquired an indexical status by becoming a trace – that is, an archive that could be accumulated, stored, exchanged, and capitalized upon. The concomitant invention of a technologically provisioned [*apparaillé*] milieu and the emergence of the face of the masses, itself contemporary with the birth of the figure of man in the human sciences, played a primordial role in the evolution of both technics *and* faces. Although studies on the photographic

portrait have discussed this reciprocal origin, they have tended to minimize or even dismiss the technogenetic specificity of the exteriorized face. More precisely, the face was part of the process of the systematic and total exteriorization of all organs that André Leroi-Gourhan sees as suggesting a *liberation from biological servitude*. The ultimate tendency of the rampant automatization that took place over the course of the nineteenth century, then, was to harness that which constitutes *what is human in man* – that is to say, his existence, his expressions, his memory. Now, in unleashing human strength for the benefit of the machine, the passage to industrial motricity also constrained the human to *adapt* and to *become one* with the machinic rhythms of modernity.

Life was reduced to a set of mechanical outputs, which brought with them a new visual culture inspired by the imagery and the imaginary of science. From this point on, the Seen would be absorbed by Totality, by a pan-optics that unveiled a *quantitative* and *qualitative* broadening of perception in which the continuous did battle with the discontinuous, the discrete came up against duration, and the actual confronted the virtual. On the one hand, it was marked, in Bergson's terms, by a 'quantitative time' – a clockmaker's time, that of a discrete multiplicity that is at once actual, discontinuous, and reducible to number. On the other hand, it expressed 'duration', that is to say, 'intensive multiplicity', continuous and irreducible to any metric. In the caesura of a world torn between the will to see all and the will to *see otherwise and to see something other*, what emerged was the representation of a divisible individual, and implicitly, within it, a logic of becomings. Being was now seen as the result of a process shaped *within* and *by* flux. Produced on a grand scale, in league with the administrative and positivist process of this

transitional epoch, the imagification of the face thus led to the breakdown of Being: the vertigo of identity reached its crisis point, in a slide toward the calculable – as if the sudden proliferation of faces had allowed the reification of the artistic genre and the end of its epiphany.

Trouble in Multiplicity

The desire to see movement, to make contact with the invisible and the infinite, was a source of great curiosity in the artistic sphere. Art and science now shared an object that had been domesticated by the experimental method – namely, time – and the new consciousness of movement brought about by mechanical vision opened up startling perspectives for modern painting. The simultaneity of points of view, the geometrization of forms, simplification, duplication, and superimposition, were all formal devices inherited from the graphic method to be explored by the newly apparelled [*appareillée*] sensibility of avant-garde artists. The structural ambivalence of flux entered into the vision of artists, rendering multiplicity turbulent and troubled. On the one hand, the thing perceived was treated in terms of metric criteria; on the other, the real suddenly seemed full of intangibles, an embodiment of the power of the virtual.

Over the course of the early twentieth century, portraits gradually lost their vocation of resemblance and instead began to pursue a synthetic vision of movement within a single image, as in Pablo Picasso's 1909 *Portrait of Ambroise Vollard*. As Peter Sloterdijk remarks, 'Face-distorting and face-emptying powers have changed the portrait into the *detrait* and the *abstrait*.'[38] The invention of photography certainly freed the creative subject from representation, but it also played its part in the

machinic turn of the sensible and the mutation of the gaze.

In reaction to mortifying metricization, painters inaugurated a process of the 'defacing' of the portrait that would gradually empty it of its existential substance. Marx's celebrated phrase 'all that is solid melts into air'[39] took on its full meaning here: all that was holy was profaned. While artists enjoyed the blooming of their creative egos, the dimension of alterity transformed into a process of *alteration*, a word whose etymology invokes the idea of change, transition, or a modified state. The inhuman element within the face started to emerge, transforming the portrait into a 'detrait' that portrayed neither face nor mask, nor indeed any unified vision of the self. These portraits from the beginning of the twentieth century were contemporary with those who experienced the confrontation with photography and the camera. From this point on, the face-to-face meeting with another, from which are born the sentiments of recognition and self-esteem, was reflected in and shaped by exchange with the machine:

> It is no coincidence that the most distinctive new place in the innovated medial world is the interface, which no longer refers to the space of encounter between faces, but rather the contact point between the face and the non-face, or between two non-faces.[40]

As the figure was decomposed, and with it the identity of things, it would ultimately be the ontology of man, of being qua being, that was thrown into doubt. The substantial nature of bodies, maintained by the stability of representation, started to dissolve into fragmented surface effects. Faces discretized by photography and shattered by the painter's touch accompanied critiques of the Cartesian *cogito* and the rise of psychoanalysis. The

unicity of being gave way to a polyvocal, heterogeneous subject, split between its conscious and unconscious instances.

Where Cubism took its lead from Muybridge's multiple exposures and Marey's panoptic unfoldings, condensing different perceptual syntheses, the Italian Futurists produced a new variant of the divisionist technique of Cubism and Impressionism with the aim of developing a 'new sensibility' adequate to urban, technicized life. Driven by a scorn for the stable, worn-out forms of the past, Futurism advocated speed and violence, aggressive motion, and the glorification of 'war, the only hygiene of the world'.[41] A tabula rasa was to be made of all artistic or historical traditions that inhibited 'Novelty' and the spirit of emancipation. In their revolutionary fervour, the Futurists called for a fusion with the very fabric of the real so as to accelerate its movement. Marinetti's 1909 Futurist Manifesto sought to compound all of the disruptions of custom and tradition brought about by the second Industrial Revolution, advocating scientific ideas but also the dreams that had emerged from them: dreams of control and of the fusion of human and machine. The Manifesto was an apologia for a machinic sensibility produced by the influence of the mass media, the acceleration of everyday life, and the new rhythms of the great metropolises. In Serge Milan's words, its aesthetic aims were oriented toward 'an individual, secular, and post-scientific ethics, which seems to make this first avant-garde movement an enterprise that paved the way for a startling cybernetic eschatology of bodies'.[42] In it, the totalitarian spirit, deployed by a panoptic technics, took on its full ideological amplitude. Marey's pure lines, as a writing of the body by measurement, now became hymns to 'the great masses shaken with work, pleasure, or rebellion'.[43] The totalitarian spectre

rubbed shoulders with the fear of and enthusiasm for the diffuse and profuse, porous and unlimited forms of a fluid world. The discretization of movement led to the liquidation of all forms, reducing 'social substance to a sort of plastic matter'[44] which would have to take on the form administered by the political project. Quite unlike the plasticity discussed by Catherine Malabou, the plasticity involved here was just an attempt to render bodies pliant and flexible, so as to unfold them according to the needs of the fascist programme. As Malabou notes:

> [F]lexibility is [. . .] at once its mask, its diversion, and its confiscation. [. . .] To be flexible is to receive a form or impression, to be able to fold oneself, to take the fold, not to give it. To be docile, to not explode. Indeed, what flexibility lacks is the resource of giving form, the power to create, to invent or even to erase an impression, the power to style. Flexibility is plasticity minus its genius.[45]

Thus determined by what they rejected, the Italian Futurists came up against the conception of *quantitative time*, making number and measure the last bulwarks against a figure in flight from all fixed definition and representation. Cleaving as closely as possible to the flows, from a perspective at once technophile (and even technocratic), naïve, and dogmatic, individuals lost all connection to the outside and to difference. They were massified, juxtaposed, in a martial logic that no longer placed them in relation and whose consequences, throughout the twentieth century, are unfortunately all too well known. Unlike Cubist fragmentation, the Futurists' project, conditioned by a technico-progressivist ideal, sought immunity from all contact, pursuing a juxtaposition that no longer placed us face to face, but side by side. Had they gone too far? Had they driven ontological deconstruction to its point of no return?

The body fragmented, taken to pieces, placed in a test tube, mechanized and prosthetized, ends up overlapping with a sexual thematic and a scopic drive which are evident today in the logic of porn. When in 1912 Marcel Duchamp painted *Nude Descending a Staircase*, with its reference to Muybridge's *Descending Stairs and Turning Around*, he was not just marking a conceptual break in his painting but signing its last testament. Inspired by the geometrical forms and chromatic palette of the Cubists as well as the Futurists' plastic and thematic researches, in this painting Duchamp attempted to give a pictorial rendering of the way in which technics had mutated the gaze, simultaneously anticipating the end of the metaphysics of the subject that was to so preoccupy postmodern philosophy.

Duchamp's *Nude* presents a vision – objectivated and even somewhat medical – of the anatomical decomposition of a figure (it's hard to tell whether it's a woman or a man). The work caused a scandal at the *Salon des Indépendants* and inaugurated the passage toward a *new perception* that would become a perennial reference point for art history. In 1996, Gerhard Richter would use the allegory of this motif when he painted *Emma (Nude on a Staircase)*, reaffirming the importance of painting in the face of the hegemony of photography. Like his contemporaries, Duchamp was attentive to the technical effects of reproducibility on the forms of art, language, and consciousness. In other words, he was interested in the modifications of the phenomenotechnical structure wrought by these apparatuses for the transcription of the real. In particular, he remarked upon how, by duplicating the same subject, technics deconstructed and reified it – an observation that prefigured Warhol's later interrogations. Since they affect not just modes of perceiving, seeing, and sensing, but also modes of judging, work-

ing, and deliberating, the technics of reproduction have transformed both sensibility and cognitive processes. Marey himself, commenting on how Muybridge's photographs were received initially with great astonishment but quickly became banal, wondered just how far this 'education of the eye' would go:

> These positions, as revealed by Muybridge, at first appeared unnatural, and the painters who first dared to imitate them astonished rather than charmed the public. But by degrees, as they became more familiar, the world became reconciled to them, and they have taught us to discover attitudes in Nature which we are unable to see for ourselves, and we begin almost to resent a slight mistake in the delineation of a horse in motion. How will this education of the eye end, and what will be the effect on Art? The future alone can show.[46]

Duchamp's *Nude* crystallized the technical and sensible imaginary of its time by elaborating a new vision of the human – animated but inorganic, asexual but poised between Eros and Thanatos. Subsequently, in *The Bride Stripped Bare by Her Bachelors, Even*, Duchamp sketched out the theme of a mechanical erotics which, in Hans Bellmer's work, would take the form of disarticulated puppets. The individual subjected to the technically apparelled [*appareillée*] gaze of science and capital became the object of scopic drives. The senseless desire to view the flux and reflux of bodies from within, from without, from above and below, from all sides, conferred upon the eye a haptic function – touching with the gaze, caressing with the eyes. Bellmer set out to discover the 'mechanics of desire' and to unmask the 'physical unconscious'[47] that governed the forms of technically apparelled sensibility; what he produced was more like a rendering of its technical unconscious.

Oscillating between Eros and Thanatos, the excess of desire and its inevitable loss, the human would now have to live alongside its non-human part – the categories of the inanimate, the artificial, and becomings-other. These disarticulated bodies constitute a stock of elements, a sort of lexicon of flows from which new assemblages can be produced. Paradoxically, it was on the basis of an image of a truly disorganized body that its image would be sought. It would be through the figure of the automaton that the deathly automatism of the body and of its desire would be combated, in favour of an infinitely modulable, nomad body – a 'body without organs', as the authors of *Anti-Oedipus* would later have it.

Between *capitalism* and *schizophrenia*, the invention of the face and the 'proper time' of its effective genesis were masked by an 'improper time' – the smooth time of a flawless development covered over what we can now see as a kind of stupor. If, as Jean-François Lyotard has argued, the work of the avant-gardes was comparable to an 'anamnesis, in the sense of psychoanalytical therapy', whose unconscious associations today reveal far more than they had seemed to, then abandoning them would lead us 'to repeat, without any displacement, the West's "modern neurosis" – its schizophrenia, paranoia, and so on'.[48] The 'post-' of the postmodern, according to Lyotard, 'does not signify a movement of *comeback, flashback* or *feedback*, that is, not a movement of repetition but a procedure in "ana-": a procedure of analysis, anamnesis, anagogy, and anamorphosis that elaborates an "initial forgetting"'.[49]

3
The Apparelled Face

Today the face is discussed in numerous scientific, political, psychosocial, and economic analyses, but this interest on the part of the human sciences is belated, and corresponds to a global disposition of knowledge. It was only around the sixteenth century that Western thought became interested in the face, and even then only as a secondary factor, the primary interest being a concern with representing inner feeling and private life.[1] In his book *Lascaux, or the Birth of Art*, Georges Bataille remarks upon the almost total absence of any representation of the face in the prehistoric epoch: 'It is not men we see in the traces that distant mankind left us as a mirror of itself. With exceedingly few exceptions, the representations are all of animals.'[2] According to art history, the first painted portraits appeared during the period of the Ancient Egyptian empire (2700–2300 BCE). But these had a funerary function – they were designed to be buried with the mummy. As Bernard Lafargue observes, the same is true of the few schematic silhouettes we find on Greek ceramics and sculpture, works in which 'only gods have a certain individuality, while men remain types, the *Kouros* being the figure par

excellence'.[3] And yet, he continues, we still do not know why

> the figure as painted face appears in the Athenian democracy of Pericles, lasts up until the portraits of Fayoum, and then disappears for nine centuries, giving way to the icon and only reappearing with Quattrocento humanism, where it gives us the most beautiful pages in the history of Western art, up to the point where Impressionism inaugurates modernity with the dissemination of water lilies.[4]

The comprehension of the 'traumatic' origin of the face between the nineteenth and twentieth centuries led us to redescribe being in terms of its technical doubling. But this *schizz*, in which the individual appeared to itself and saw itself via the mediation of an object, is only one stage in the long process of the exteriorization of the face which began not in the machinic era but on the threshold of our Judaeo-Christian civilization. Now we have established the phenomenotechnical dimension of the face, it remains to analyse this exteriorizing character more precisely, so as to evaluate what it was that motivated the human to *re*-present itself – that is to say, to present itself twice over.

According to André Leroi-Gourhan, this exteriorization is the endpoint of an emancipation that began with upright posture, allowing the hands to be freed from the constraints of locomotion, which in turn released the jaw from its prehensile function, leading to the development of the facial muscles, the appearance of the chin, the advance of the forehead, the redistribution of the skull, an increase in the volume of the brain, and the descent of the glottis and larynx so that speech could develop. Human evolution therefore 'did not begin with the brain but with the feet';[5] however, Leroi-Gourhan analyses the process of hominization in terms of the gradual

specialization of two corporeal zones: the hand and the face.

The face first emerges by way of a *detachment* in relation to mammalian muzzles: 'We refer to this biologically and culturally motivated setting apart of human faces from animal faces as *protraction*,'[6] notes Peter Sloterdijk. This 'action of drawing forward', of revealing, of *extracting* the human face from animal muzzles, corresponds to the inception of a new 'interfacial space' in which '[t]he opening up of the face – even more than cerebralization and the creation of the hand – enabled people to become animals open to the world, or, more significantly, to their fellow humans'. This opening up of faces is a kind of unveiling through which humans expose themselves 'to the threshold of portrayability',[7] a device that answers to the necessity of *ek-sistence*, meaning that the individual stands both within and outside of himself. Through this movement of specular phenomenology, a face-subject gains the experience of his other: his face-object.

Because man has access to his own figure only via the mediation of an object separate from himself such as a mirror, a photograph, or a screen, the face is by definition always that of the other, in the play of a face-to-face in which man 'is only visible to himself if he is divided'.[8] The impossibility of immediate self-perception has made the face 'paradoxically the best known and most heavily invested place (and time) of the body, to the point where it is what identifies the individual, while at the same time it remains the most foreign'.[9] In becoming a materialized retention, the face-object was transformed into a technical augmentation of the self. The face is no longer a double but is instead an extension of the self, or even a prosthesis that mitigates its intrinsic limits.

Understanding the face in this way reveals how wrong

we would be to take for granted the idea that humans are beings fundamentally constituted by technics. For although this idea is broadly discussed in contemporary discourse, something still resists: a sort of 'Promethean shame',[10] as Günther Anders calls it, which makes it necessary to continue to argue the case. Confronted with the perfection of the instruments that he fabricates, man is ashamed of himself, ashamed of his contingent origin. Suggesting that the face first appears in 'year zero' – that is to say, with the birth of Christ – Gilles Deleuze and Félix Guattari assessed this programme of *facialization* which Sloterdijk calls, laconically, the 'Christogram'.[11] The face was first of all that of Christ, in the sense of the average generic White Man, and discrimination did not proceed via exclusion pure and simple but via the determination of deviations from this type of face. Such was the functioning of the 'abstract machine of faciality'. But if Deleuze and Guattari laid the groundwork for a non-Levinasian thinking of the face, they failed to highlight the *default of origin* that makes of the human an essentially incomplete being that must, as the Promethean myth suggests, endow itself with *artificial organs* so as to compensate for this incompleteness. The creation of the mask was the institution of such an organ, the invention of an *other* memory, not strictly a biological one, but precisely a *mnemo*technical one.

The Default of Origin

A great deal of contemporary art has centred on the mask. Consider the use of masquerade in the work of Claude Cahun, Cindy Sherman, and Gillian Wearing, whose practices attest to a renewed interest in metamorphosis, make-up, and masks. Why do artists persistently return to this canonical figure? Perhaps masquerade

makes it possible to explore different facets of the 'self'
– but then why do these artists find it necessary to photo-
graph the mask, sometimes in isolation, apart from any
subject? Could we understand the 'return' of the mask
as the sign of a deeper unease, born of the proliferation
and exponential diffusion of faces since the invention of
photography? For it seems as if contemporary regimes of
the image brought to the surface that 'initial forgetting'
from which emerged the human as a being essentially
constituted by its artefacts. From existential quest to
autofiction, contemporary art's experimentation with
the 'I' of the mask seems to gesture toward an acknowl-
edgement of its 'ego-technical' nature.

In the Greek tradition, however, the mask was not
something that masked. On the contrary, it was 'that
which lies before the eyes' or, more exactly, 'that which
lies before the eyes of *another*', and it was not distinct
from the 'face', which was defined as '*prosôpon*', as
was the 'façade' of a building.[12] Among the Latins,
on the other hand, the etymology of the word for
'mask', *persona*, distinguishes it from the face, which
is designated by '*vultus*' or '*facies*'. The word *persona*,
which translates the Greek *prosôpon* and is the direct
ancestor of our 'person', was long understood by the
Romans themselves to derive from *per/sonare*, that is,
the mask *through which* (*per*) the voice (of the actor)
re*sonates*. Etymologists today dispute this sonorous
origin, instead 'finding its root in the obscure figure of
the Etruscan Phersu, an infernal demon related by name
to Persephone, queen of the dead, and Perseus, both
of whom held aloft the Gorgon's head'.[13] The Latins
saw the mask as a 'power that emerged from the abode
of darkness, of the invisible and the formless, the world
where there are no longer any faces'.[14]

Throughout Antiquity the notion was enriched with

new meanings, leading Hellenist Françoise Frontisi-Ducroux to speak of the 'avatars of the *prosôpon*'.[15] Pierre Hadot adds that the semantic quarrel in Judaeo-Christian culture between *persona* and *prosôpon* is also linked to the entry of these terms into Christian theological disputations,[16] where the *daimôn* was associated with *psukhè* (breath), confirming the opposition between soul and body. This connection between the diabolical and the mask, which from this point on will fool and dissimulate, probably explains the attraction to satyrs and disguises characteristic of the Middle Ages, and whose theatrical development would give rise to *commedia dell'arte*. But it also enables us to understand the suspicion of faces that would later lead to their being disregarded in favour of icons and their impersonal and universal character. If God created man 'in his image', by tasting the forbidden fruit the primordial couple definitively lost this divine resemblance. According to Edmond Jabès, '[F]or the creature to seek, in spite of everything, to have a face, would therefore have meant that in its tenacious will to exist, it *invented* this face.'[17]

From the beginning, myth and the great monotheistic religions alike have viewed the human figure as an absurdity, the fruit of an original sin that brought with it blasphemy, idolatry, and the fetish. Islam's stance on the face and the image was no doubt warranted by its relation of filiation with and opposition to the great monotheistic religions that preceded it, Judaism and Christianity. In this respect, Islam was heir to the second commandment of the Law of Moses. The veil was considered as the trace of an ancient conflict of visibility between Hellenistic and then Christian cultures, which considered sight as the most elevated of the senses, and a religion that remained suspicious of the gaze because it is the libido's closest ally. The veil, whose generic and

legal meaning signifies 'hidden' or 'separate', became that which screens between exterior and interior, man and woman, public and private, like an intermediary or a mask.

This brief and cursory detour via its origin story prepares the ground for a critique of the face as it is today. These semantic and religious sedimentations that lie beneath the concept of the person, amalgamating face, mask, façade, and then, under the influence of monotheistic religions, the Manichean notions of soul and body, visible and invisible, scopic and libidinal drives, account for its controversial dimension. But they also highlight a default of origin and a process in which man invents himself, as person *and* as prosthesis, via the face. 'Man is only man', writes Stiegler, 'in so far as he places himself outside of himself, in his prostheses. Prior to this exteriorization, man does not exist.'[18] Although the term 'exteriorization' is unsatisfactory 'since it supposes that what is "exteriorized" was formerly "within"', which is precisely not the case',[19] it nevertheless highlights the prosthetic aspect of the face. The *pros-thesis*, like the mask, is that which is placed in front, namely that which 'is outside, outside what it is placed in front of'.[20] The prosthesis therefore does not serve to make up for a lack, to compensate for a loss or to repair a deficiency, so much as to add *spatially* and *temporally* to that which is:

By pros-thesis, we understand (1) set in front, or spatialization (de-severance [*e-loignement*]); (2) set in advance, already there (past) and anticipation (foresight), that is, temporalization.

The prosthesis is not a mere extension of the human body; it is the constitution of this body qua 'human' (the quotation marks belong to the constitution). It is not a

'means' for the human but its end. [. . .] It is the process of anticipation itself that becomes refined and complicated with technics, which is here the mirror of anticipation, the place of its recording and of its inscription as well as the surface of its reflection, of the reflection that time is, as if the human were reading and linking his future in the technical.[21]

The exteriorization of the face onto a secondary support that plays the role of Derrida's *supplement*[22] allows the human to *invent itself* as such. As soon as the two-fold capacity for toolmaking and symbolic expression is acquired, the becoming of man can be understood as a process of the exteriorization of all of his operational sequences. The mask *augments* [*appareille*] the face; it is an *artificial organ* for the face. More than just a simple prosthesis extending the limited capacities of the human, it is the result of an act of self-creation that 'innervates' the body: once *appropriated*, it becomes a creative element that fuels the emergence of a singularity. Innervation, like appropriation, involves the adaptation of an object to a particular recipient or function in view of rendering it 'proper' to itself.

The invention of the *prosôpon* and the ensuing controversies testify to the difficulty in acknowledging the pharmacological dimension of such technics. Icons, satyrs, and veils can be seen as so many stratagems allowing us to circumvent the prosthetic and therefore technogenetic dimension of the face. Even today, when technics is extolled in discourse, we cannot bear to think the non-human in man, so much does the face crystallize the apex of the individual, and technics constitutes an alienating operation tantamount to a kind of non-being. '[I]n the features of the face the soul finds its clearest expression,' Georg Simmel tells us in 'The Aesthetic

Significance of the Face'.[23] This widely shared notion, however, disregards the *organized inorganicity* of the face, that is to say, its mask, whose prosthetic dimension functions as a supplement. A supplement, as Derrida specifies, is that which 'adds', which is a surplus, a plenitude enriching another plenitude, the *height* of presence. But the supplement adds only to replace, it 'insinuates itself *in-the-place-of*', in a place assigned in the structure by the mark of a void or, in other words, a default of origin. So that 'in fabricating, man has fabricated his psychological functions; he has expressed himself in his works and his works have acted upon him'.[24] From which there results the problem of the person, and the challenge, for each of us, of constructing ourselves as a person.

An Artificial Organ

The formation of the 'category of person',[25] as brought to light by Mauss, testifies to an imaginary that has accompanied and influenced the history of the subject and, with it, the development of societies, religions, languages, technics, and the arts. Mauss made a major contribution to undoing the presupposition that the idea of person, and with it that of the 'self', is 'natural' or 'innate'. Indeed, these notions are so deeply entangled with Western culture that any attempt to erect them into universal categories would rightly be suspected of ethnocentrism. It is interesting to observe that many languages, from Latin to Spanish, and including Italian and Portuguese, have no need of a pronoun to mark the personal form, unlike French, English, and German, whose sentences are characterized by the presence of 'je', 'I', or 'ich'. The languages of the Far East go even further in this direction: the notion of *person* in Indian

Buddhism functions in terms of classes and hierarchies, and the absence of any mark of the subject in Japanese testifies to the impersonal or transpersonal character of the language that functions as a mirror.

The Greeks of the archaic and classical epochs had no consciousness of a delimited and unified self. For them the self developed through experience, 'turned outward, not inward',[26] there consequently being no place for introspection, for turning in on oneself. The subject was wholly extraverted, its identity confirmed in the public arena through the gaze of others. It is this orientation toward the outside and this peculiar relation to alterity that explain the gap between Greek manners and the modern idea of a subject closed in upon itself, confirming itself solely through the mediation of its own consciousness. Descartes's *cogito ergo sum* would have made no sense to the Greeks since they had no reflexive construction: others think of me, therefore I am. The Other takes the place of the personal mirror: it does not furnish an eidetic reinstatement, but posits itself as the *echo of an affect*.

In *Dans l'oeil du miroir*, Françoise Frontisi-Ducroux provides a phantasmagorical survey of Ancient Greek conceptions of the mirror, which have a great deal to tell us about attitudes toward technics that are still with us today. Men, she explains, were prohibited from owning mirrors, for they represented a twofold danger. That of introversion, 'which would be fatal to the male individual, as it is for Narcissus',[27] for his vocation is to be open and social. And that of alienation, of 'being assimilated to a reflection sent back by an object, *implying a quasi-reification*'.[28] The mirror was reserved for woman, whose condition was precisely one of reclusion and closure. 'As for alienation', Frontisi-Ducroux tells us, 'there is no risk of this, since woman is *other*

by definition. She is already object.'[29] The belief in an alienating technical imaginary originates in the assimilation of the object to the individual, which helps explain those fears linked to the exteriorization of the face onto a secondary support.

The Ancients' disquiet was occasioned by the fixed and unilateral character of this specular relation. The mirror, which resembled a polished metal plate, reified and fixed the person just like Medusa, and could be deadly, as the myth of Narcissus served to remind men.

Greek man did, however, use intermediary devices which, while not reifying, could act as go-betweens fuelling his imaginary by serving to *complete* his self. Cups and amphoras, in particular those representing the image of a drinker from the front, and which were passed from hand to hand during banquets, played the role of an 'intellectual operator'.[30] If, as Sloterdijk suggests, metaphysics began with a 'metaceramics',[31] it is because potters were the first to discover that the earth from which Adam was made is more than just soil to be tilled. In this way the production of vases would have opened up a metaphysical horizon by way of the question of technics. Rejecting the apotropaic thesis that vases topped with large eyes are meant to ward off the 'evil eye', Frontisi-Ducroux, who insists on the non-masking character of the *prosôpon*, considers these head-vases to be doubled faces, watching both the drinker and his neighbour at the banquet. Drink can be revealing in two ways, delinking speech from social conventions and offering a reflective surface to the male: 'wine is the mirror of the soul', as Aeschylus says. The 'face-vase' or '*prosôpon*-vase' furnished drinkers with 'images of another self or of a self that is already other',[32] images that function like a series of more or less deforming, *altering* mirrors. But these face-vases also displayed

masks of a yet more radical *alterity*: that of the divine in the figure of Dionysus, that of semi-bestiality in the hybrid satyrs, and that of chaos and death in the form of the Gorgon.

Thus alterity and alteration participate in the construction of the individual. Arthur Rimbaud's famous 'I is another' finds itself vindicated here, since there is no line of demarcation between the face and the different masks that an actor wears, between a proper identity and a borrowed identity. Greek manners, which link the face to the mask and the *prosôpon* to the other, express the traits of an interiorized projection – that is to say, a projection that has been appropriated, turned inside out like a glove. If the face 'dissimulates nothing', but on the contrary 'expresses and reveals' – which implies that *there is nothing behind it* – it always acts so as to present to others the living and visible, changing and plural aspect of the *prosôpon*. The Greek *prosôpon* was therefore the ongoing result of continual constructions and deconstructions. Essentially fluid and polymorphous, it immediately adopted a diversity of masks as so many *artificial organs* from which one could *adopt* an identity. This outfolding, however, was still bound to the reciprocal experience of the interfacial encounter. It was only when man turned away from the other to turn toward his own face that he would become, to himself and for himself, his own complement. And it is from this relative *autonomy* that the notion of the person would be born.

According to Mauss, the notion of person stems from a simple masquerade that evolved stage by stage into 'the mask, from a "role" (*personnage*) to a "person" (*personne*), to a name, to an individual; from the latter to a being possessing metaphysical and moral value; from a moral consciousness to a sacred being; from the latter to a fundamental form of thought and action'.[33]

No one can be sure of the direction in which the category founded here may evolve, or even whether it will survive in the face of recent progress in psychology and technics of appearance such as photography, digitization, and the mobile telephone. What we can say is that with its emergence, for the first time in the history of humanity the person, up until that point only a character circumscribed by dances, rituals, masks, and a system of mythical representations, became the fundamental and universal locus of the *rights of citizens*. From this moment on, in Ancient Rome, to *have* a person would signify, first and foremost, *possession* of a legal-political personality. As for slaves, since they were not members of any *gens*, any lineage that would entitle them to inherit a name and a mask, they could not *have* a *person*, that is to say, a legal status. The Latin appropriation of *prosôpon* thus sets out from a legal archetype, from which the *law* and the function of the citizen will emerge. In his essay dedicated to the development of the categories of 'self' and 'person', Mauss insists on the precariousness of this right, which could be usurped at any moment:

> It would suffice to kill the one possessing them, or to seize from him one of the trappings [*appareils*] of ritual, robes or masks, so as to inherit his names, his goods, his obligations, his ancestors, his 'person' (*personne*), in the fullest sense of the word.[34]

Let us recall here that, in Rome, at the funerals of patricians, waxen painted masks called *imagines* were worn by men of the same height as the departed in the funeral procession. Unlike Egyptian portraits, however, these highly realistic effigies were not deposited in their tombs but scrupulously conserved in wardrobes. Only the patrician families had a *jus imaginum*, a right to the image, and

they would exhibit these *imagines majorum*, portraits of the ancestors, in the atrium of their *domus*, a prefiguration of the portrait galleries of the bourgeois class in the era of photography, or the virtual vitrines of Facebook.

The translation of the word *persona* into 'person' would end up retaining the sense of a superimposed image, but would suppose a minimal gap detaching the person from their mask, which now became an opaque object that dissimulated, fooled, and divided. The development of the notion of *person* thus articulated a logic of *ceremony* and *preparation*, with the suggestion that appearance prevailed over being. As a device of ceremonial pomp and adornment, the mask augmented [*appareillait*] the individual, rendering him worthy of appearing – so rather than self-consciousness, it was consciousness of a particular function that drove man to represent himself, while the meaning of this consciousness had to lie in a *poietic activity*. Through acculturation, this common usage of *persona* in Latin also became current among the Greeks. As Epictetus states, in a phrase cited by Marcus Aurelius, morality demands that you 'carve out' your mask, put on 'your "role", your "type", your "character"'.[35] According to the Stoics, man is formed and educated only through *techniques of the self*. Technique may be deindividualizing, but it also made individuation possible. The construction of one's singularity was enabled by a set of techniques of the self and of the body which, repeated and ritualized, also formed a memory surface for inscription. Assured of himself, the citizen could realize himself through his own efforts, and was obliged to do so. Casting aside the other, man now supplied his own law, narrowing down his vision in a quest for an *autonomy of the self*.

*

This is what photography and the mass commercialization of mirrors in the nineteenth century amplified and revealed. 'Naked life', considered by the Greeks as 'a purely biological datum',[36] was a fiction for theologians; the construction of the self could only be the result of the adoption of increasingly discreet technical augmentations [*appareillage*]. But from the very moment when men were able to see *themselves*, in their nascent individualism they adopted 'the perspective of an outside view on themselves, and thus augment[ed] their interfacial spheric opening with a second pair of eyes that, strangely enough, were not even their own'.[37] It is this doubled gaze, at once familiar and foreign, that lies at the origin of the *narcosis* of the face. It looped the gaze in on itself, further fuelling the fiction of autonomy. Rather than confirming an irreducible consciousness, the hypostasized notion of self only highlighted the fact that the Other had now been replaced by technical means of self-complementation.

And yet the path leading from the Christian *persona* to the category of 'self' qua psychological being is lengthy and littered with controversies. In initiating the *cogito*, Descartes made the qualitative leap into a consciousness that now *thought itself* and *reflected itself*, in doing so differentiating itself from both animal and machine. In its strict autonomy, this consciousness that ensured the subject's mediation with itself in total transparency was bound to become atomized, precisely because it sought to do away with all mediations (the other, alterity, alteration, the object, the image) by positing itself as sole legislator, *in itself*. Hence its transparency harboured a dark side which Descartes, within the framework of his dualism, attributed to matter, and in which Freud would later discern a psychic unconscious.

The mask, which might be thought of as the archaic

version of photography, is therefore a portable identity. It is a materialized retention that can be worn. The fact that the word '*persona*' retains the meaning of a superimposed image suggests that the invention of photography probably played a twofold role in the development of Jung's theory of the persona. On the one hand, photography activates reminiscences and archetypes of the mask as doubling and exteriorization. On the other hand, by heightening nocturnal life, projections, and phantasms, it deepens the split between the daylight portion of our social self – now visible in images – and the unlit and unconscious part of the psyche. Like Lacan with his 'mirror stage', Jung seems to have produced a discourse that relies on the non-discursive formations of his epoch and the cosmetic products available in the great metropolises. According to Sloterdijk, these discourses are beholden to the 'ego-technical household inventory of the nineteenth century'.[38] He criticizes Lacan for this orientation of psychoanalysis toward the image at the very time when, with the commercialization of mirrors and the invention of photography, images are proliferating and becoming banal. According to Sloterdijk, Lacan was the victim of his own narcosis before these images. And yet we must admit, with Lacan, that the formation of the 'I' is indeed nurtured and affirmed to excess in the mirror's comforting, unified reflection. The reproduction of faces on a grand scale during this period consolidated the conditions of possibility of a schizoid discourse wherein the individual identified with his face-object, that is, with the reflection of his objectivated self, there no longer being any need for the other. So there emerged the fiction of autonomy, and then subsequently a return to the preoccupation with masks and masquerades within our postmodern societies, which are above all societies of image and spectacle.

The Ego-Technical Complement

Between the end of the nineteenth century and the middle of the twentieth, autobiography and self-portraits were hugely popular genres. From the anonymity of crowds to nascent individualism, this period saw the flourishing of a society that was entering into globalization while simultaneously being diffracted in an infinity of mirrors, reflections, shop windows, photos, and various other images. Masquerade became rather fashionable at the end of the nineteenth century. Artists such as Nadar, Pierre Loti, and Charles Nègre would pose their clients, interpreting bourgeois style in a theatrical and codified fashion. Yet these portraits remain marked by a romantic vision belonging to the 'golden age' of travel, and by colonialism and exoticism. The quest for alterity, often stereotyped and reduced to clichés, in reality denoted a certain racism and a fascination for the foreigner that heralded far more sinister diversions.

Claude Cahun, born Lucy Schowb, was one of the first to conceive of the masquerade as a practice of the 'writing of the self'. From 1913 on, she developed a practice of self-portraiture in which the mask was discovered as a means of becoming-other, a way of constructing one's personal mythology, inventing oneself from day to day. Cahun adopted multiple roles, poses, and disguises, making herself by turns man, androgyne, marionette, angel, and demon, trying her best to drive out from herself any unified and fixed identity by exposing her true face to all eyes. 'Under this mask, another mask. I will never finish removing all these faces,'[39] she wrote in 1930. Pursuing an existential quest in a battle against melancholy, sexual heredity, and self-destruction, this artist introduced into contemporary art the problematic of multiple fictions of the self, but

also unwittingly suggested a reflection on the becoming-artefactual of human evolution. The masks fall, and yet others appear, revealing their creative potential. Cahun died in 1954 and, in spite of her influence on the surrealists, rediscovery of her work came rather late. The artist's first solo exhibition took place in New York in 1992, and in the same year François Leperlier published his monograph *Masks and Metamorphoses*.[40] But this was also the moment when the debate stirred up by 'French theory' began to break out in the United States as, within cultural studies and gender studies, identity began to be understood as the effect of the *formation* of power, of sociocultural or political *constructions*, and homosexuality as a specific product of the modern bourgeois Occident. The genealogical reconstruction of these categories in the light of Greek *Eros*[41] propelled the winds of change through collective consciousness. By questioning the limits of her own identity through masquerade and the staging of the self, Cahun had affirmed the desire to appropriate for herself a new face, one that would be chosen and freely shaped. Political conditions and conventional mindsets may not have been ready for this in her own time, but they would soon catch up. Gender studies would welcome with open arms the themes of metamorphosis, masquerade, and the myth of the androgyne. Transvestism would signal the death of a hypostasized self in favour of a freedom of choice. What was at stake in Cahun's approach took on a different inflection at this point. Seen as anticipating and confirming postmodernist claims, her oeuvre began to be read in terms of a challenging of sexual distinctions and binary identities – an understanding that passed by way of a critique of gender according to which womanliness, as Joan Rivière and Judith Butler announced, is itself a 'masquerade'.[42]

The Apparelled Face

Beyond sexual metaphor, at a deeper level it was the very foundation of identity that was being challenged here. The mask embodied the possibility of a break with the biological, social, and political order. The famous 'know thyself' was replaced by the injunction to 'complete yourself'. Individuals would now have to become what they were by appropriating the exteriorized image that mirrors reflected back to them, that photography presented to them, that the media imposed upon them. The multiplication of images of oneself reinforced the idea of a plural identity caught between two kingdoms, living 'between the animality that constitutes it and the representations that it constitutes'.[43] Images became a medium in which identifications could be reformed and problematized. Dispensing with the notion of an existential quest, it became instead a question of acknowledging the *egotechnical* and *pharmacological* nature of the mask. Whereas Cahun had interrogated her identity in terms of the numerous possibilities of being *other* than oneself, her avowed aim being to attain a third gender, for artists such as Gillian Wearing and Cindy Sherman, play with artifice and prostheses is an end in itself; the problematic slides from prosthesis toward that of ostentatious adornment and positive reification.

The face is a technical object, at once prosthesis and memory support, face-subject and face-object. Qua technical, it is constituted by acts of *writing of the self* that imply participation in a logic of the circulation of the gaze. In this respect there are more ambitious motives at work here. Certainly, the prosthesis, in so far as it is that in front of which it is placed, prompts us to consider the technical exteriorization of the face, but it doesn't help us grasp the 'creative' dimension conveyed by the notion of 'apparatus', which suggests more complex operations that transform sensibility and memory

55

along with the most intimate dimensions of the psychic apparatus. For the apparatus is not just an interplay of techniques, defined by their function; it develops by multiplying connections and mental operations between people and *between* their images.

The various series of works made by Cindy Sherman, starting with *Untitled Film Stills* (1977–80), where she takes on the stereotyped traits of 1950s women, up until her arrival on Instagram in 2017 by way of the *Clowns* series made following September 11, in each case testify to an ardent desire to incorporate her photographs into fiction and artifice. 'Everything in the picture', as Arthur Danto comments, 'is fake – fake breasts, fake cloths, fake Raphael. Only the picture itself is real Sherman.'[44] The proliferation of wigs, accessories, and prostheses in her *Untitled Film Stills*, just like the projections and the abundance of colours and psychedelic forms in the *Clowns* series, have no explicit meaning other than a short-circuiting of reflexivity, disrupting any straight-forward return to self. Here the question of identity, so crucial in the practice of self-portraiture, is a snare. Sherman is motivated neither by intimacy nor by the disquieted existence of a subject faced with their own appearance, as in Nan Goldin's numerous mirror por-traits. But if neither the depths of identity nor feminist claims seem to preside over Sherman's metamorphoses – although these problematics undeniably crop up – then what are these relentless stagings with the equivocal title *Untitled Film Stills* trying to tell us?

Sherman's ceaselessly reiterated exhibiting of her face has long surpassed the nostalgia for a narcissistic self. On the contrary, the *Untitled Film Stills* series only reinforces the desire for the loss and disappearance of the self in favour of the construction of new regimes of fiction. The ludic and critical dimension of Sherman's

work generates new worlds and temporalities with the aim of producing and fictionalizing the self, and in this respect it goes beyond the care of the self, the concern for filiation, and the smearing of genres, and seeks a more global modification of our thinking. The exuberance of artifice becomes a way of making things and the world *appear*. As Jean-Louis Déotte clarifies, the apparatus [*appareil*] 'is that which lends to appearance all its ceremony [*apparat*]'.[45] The term *appareil*, which comes from the Latin *apparatus* (from *apparare*: to prepare for), signifies *preparation* – and enters into the meanings of apparatus, ceremony, lustre, décor, and secondarily *dispositif*, prosthesis, instrument, engine, and so on. In Sherman's work there is no longer anything apart from décor and ornament; her practice assembles an apparatus that operates a singular articulation of art, thought, and technics, but also the objects and events of the world. All of these prostheses, which are so many ways of amplifying human capacities, individual *and* collective memory, open up a fictional space that describes new collective temporalities and experiences. So that the themes of transvestism, metamorphoses, of the androgynous or of multiple identities that burgeoned throughout the twentieth century seem like a law of gender within practices and discourses, precisely because they pervade our epoch with such necessity – the necessity which Alain Badiou, in *The Century*, has called the 'passion for the real and the montage of semblance'.[46] According to Badiou, the art of the twentieth century was a reflexive art that encountered the real by exposing the means of the factitious. The real, the bare, was given only through the mask or the semblance, so that, given the impossibility of differentiating between real and semblance, suspicion was always in order, and truth was to be found in the gap and in difference.

At the turn of the twenty-first century, masquerade became an act of performance, involving the public practice of regulated repetitions and stagings which took the form of a strategy for the exhaustion of images and signs of the self through the creation of images of images. Sherman's devices immersed memory in a mirage of artifices and surface appearances where the flux of images and the serial construction absorbed sense and the senses. Losing herself in the proliferation of images of herself, the artist demonstrated how the subject could disappear into the codes of representation and reification. She was engulfed in liquidity in the twofold sense of flux (of images) and fluidity (of identities). Although to some extent Sherman's face still remained the bearer of intersubjectivity, of cultural and collective memory, over time it was progressively reduced to a pure image speaking (to) other images with no means of returning to the real or to the self: a face become sur-face.

Masked Repetition

Transvestism and masquerade have now become commonplaces in contemporary art, testifying to a renewed interest in the politics of representation. The crisis of representation brings with it a crisis of identity, and vice versa, with both calling into question their power of truth and identity. This falsified truth, its norms and codes turned inside out, was also parodied in the competitive performances of voguing in the 1990s: for the duration of a parade, voguers would become a 'real man' or 'real woman'. Referencing a debate that opposes the term 'realness' to that of 'passing', where the latter denotes mere lies and the notions of true and false, Lalla Kowska-Regnier[47] has suggested we should question the very notion of reality and authenticity. Rather

than *identifying* persons and passions, she suggests that we should *authenticate* roles, select masks. The truth of the naked, as Deleuze warns us, is the mask. In fact, the grammatization of perception instigated in the nineteenth century would throughout the twentieth century be associated with new potentials for the deployment of the self and the real. The role of the device [*appareil*] was progressively reversed; today it is no longer instituting, but instituted. It is affirmed as the possibility of a plastic vision, not as a plasticity of vision, thus heralding the passage from flux to fluidity.

Andy Warhol was the first to take the radical approach of adopting a repetitive, mechanical, automatic, almost monotonous gesture. He raised everyday objects such as tins of Campbell's soup to the rank of artworks, but he also subjected the concept of the personality cult to a détournement by producing variants of the same face in various media and multiple editions, like promotional items. These faces, with their smooth, textureless surfaces, multiplied like mere manufactured objects, seem emptied of all substance. 'There's nothing behind it,' as Warhol liked to say. With these practices, he established an aesthetic of repetition that brings together the operations of effacement, presence, presence through effacement, and repetition as a mode of the manifestation of the real. Whence the paradox noted by Deleuze:

The more our daily life appears standardised, stereotyped and subject to an accelerated reproduction of objects of consumption, the more art must be injected into it in order to extract from it that little difference which plays simultaneously between other levels of repetition, [. . .] in order that Difference may at last be expressed with a force of anger which is itself repetitive and capable of introducing the strangest selection, even if this is only a contraction

here and there – in other words, a freedom for the end of a world.[48]

Hence repetition 'presents itself as the pharmacological object par excellence'.[49] 'If repetition makes us ill, it is also repetition that cures us; if it enchains us and destroys us, it also liberates us.'[50] Deleuze distinguishes between two types of repetition: 'One is bare repetition which can be masked only afterwards and in addition; the other is a clothed repetition of which the masks, the displacements and the disguises are the first, last and only elements.'[51] It is in light of this distinction, he tells us, that we should understand the death drive in its relation to masks and disguises. For the author of *Difference and Repetition*, '[P]hysical, mechanical or bare repetitions (repetition of the Same) would find their *raison d'être* in the more profound structures of a hidden repetition in which a "differential" is disguised and displaced.'[52] These deeper structures of a repetition qualified as 'clothed' or 'disguised' – as opposed to brute, bare repetition – develop through the death drive. This clothed repetition is not a disguising disguise adopted by a subject in order to veil a reality, but on the contrary a transvestism that continually constitutes the subject. When Deleuze speaks of disguises and masks to designate the repetition that is the death drive, he is not being metaphorical, for '[t]he mask is the true subject of repetition'.[53]

At the most profound level, our psyche is always already constituted by repetition, which ceaselessly undoes and reinvents roles and masks; it is essentially plastic, in the sense proposed by Malabou. It is no surprise that Warhol, in the lineage of Claude Cahun, plays at disguise and masks, in a continual desire for the metamorphosis of identity. If the mask is not that which

hides but that which makes appear, it also lies at the origin of the prosthetic and artificial nature of the face, as well as being the endpoint of any thinking of being that does not *reflect* itself in and through its artistry or, in other words, its positive reification. With Warhol, then, a twofold struggle is joined: a deconstruction of *ontologies of being* in so far as they were programmes of closure, and of *ontologies of pure becoming* in so far as they could think the object only in a degraded form.

*

At the beginning of the 2000s, the French artist Valérie Belin focused her practice on the ambivalence between presence and absence, animate and inanimate, and the contradictory alliance between the image of an object that suggests a body and the image of a body transformed into an object. In doing so, she adopted the systematic use of series in an attempt to exhaust a motif inspired as much by American minimalism as by a will to reification – a Warholian gesture echoed in her treatment of objects which, by virtue of the photographic apparatus, acquired a strong presence, while human figures became increasingly spectral, irreal, or thinglike, as in the series of *Black Women,* in which bright whites cut into the shoulders of the women, shaping them into pedestals. Although Belin's work was haunted by the question of doubles and lookalikes, it was the vertigo of the image that lay at the heart of her practice. According to Belin, '[W]e are seeing a reduction of the living being to pure image.'[54] 'What are we made of?' she asks. 'Is there some kind of essence? Or are we just appearance, an envelope that can be shaped as we choose, pure images?'[55] Simultaneously, the artist Kimiko Yoshida pushed this logic of transformation by the image to its extreme, by herself progressively becoming image. 'I'm

interested in everything that isn't me,'[56] she declared. Through her series of almost monochrome self-portraits, her identity appears, then disappears, only to reappear once more. Japanese by birth but resident in France, the artist suffered a twofold exile – that of the expatriate and that of flight into the image. She thus became doubly foreign to herself, foreign to both her subject-face and her object-face. Ultimately it was the image that reflected itself, making perception float free. Yoshida sought to fuse with a dimension of universality concretized in large square-format photographs that oscillate between the establishing of a presence and a vanishing into colour. Often white and diaphanous, her works have the allure of Malevich's supremacist paintings. In them we read a staging of minimal but absolute difference, imbued, as Badiou writes, with a 'passion for the real that is obsessed with identity, to unmask its copies, to discredit fakes', a passion for the real that is 'differential and differentiating [. . .] devoted to the construction of a minimal difference'.[57] This tension, which is always at work in our epoch, relates to a commitment to beginning and renewal that is materialized in a pronounced taste for surfaces and appearances.

For some years now, one of the characteristic aspects of contemporary photography has been the format of its images. Throughout Sherman's *Untitled Film Stills*, the images become larger, the face very soon becoming nothing more than an objective presence, that is to say, an objective datum rather than a subject objectivated by the camera, as was the case in the nineteenth century. If this tendency in Sherman's work confirmed a stance of subjection and immersion in the image, it also manifested a slippage of the gaze whereby photographic *vision* was erected into a norm for the epoch. The face was no longer the subject of the image: the photographic image,

objective and independent, systematic and procedural, became its own subject. The vanishing of the face into the image was the symptom of a face become surface, as smooth and pellicular as the medium itself. Yoshida's diaphanous, spectral self-portraits gesture toward a beyond of the gaze that interrogates the contemporary ecology of images: these atmospheric images envelop us, where Sherman's colourful images tended to induce a hallucinatory gaze dizzied by the vertigo of pastiche. One steps serenely into the image where the other became restless and lost herself. Sherman practised an art of excess; Yoshida experiments with an aesthetic of escape, all transparency and lightness. Stepping through the mirror, Yoshida explored all sorts of life scenarios that challenge 'a whole historical period of images marked by an ontological concept of mimesis'.[58] In Sherman, on the contrary, the *Clowns* series seemed to manifest this double malaise, brought to its climax by the multiplication of images at the turn of the digital age. It is only one step, after all, from clown to clone.

The Narcosis of Narcissus

In these images we see a schizoid reflection of man faced with his doubling, or perhaps his extension. It is thus no longer man, but the projected image, in other words his extension, that is being probed. The year 2000 inaugurated the new millennium, but also followed the explosion, in 1997–8, of the market in compact digital cameras capable of instantaneously diffusing and multiplying images of the self and of the world. Where film photography had accompanied modernity in its search for interiority, digital photography would explore the conquest of exteriority. These machines, which in their everyday use are above all extensions of

memory, stimulated an appetite for the accumulation of and experimentation on self-images. Sherman's *Clowns* series, along with Roni Horn's works with the same title, both made at the beginning of the 2000s, would become manifestations of a short-circuit. The tutelary figure of the clown, whose transgressive character has returned in every era, now seemed like the reflection of a humanity repeating itself to infinity, drowning in its fascination with its own images.

As Marshall McLuhan suspected, the Greek myth of Narcissus is directly related to a real dimension of human experience. For Plato, the image reflected in the mirror was a kind of secondary object similar to the original but whose image was situated on the side of non-being. It belonged to appearance, to the fake, the illusion. Psychologists have provided abundant commentaries on Narcissus in terms of a self-love or love of one's own image that may lead to psychic imprisonment or impossible alterity, among other possibilities. One variant of the myth recounts that at Narcissus's birth the oracle warned his parents that he would 'live a long time but would never know himself at all'. Elsewhere we are told that a spurned lover placed a curse on him so that he should never possess the *object* of his love. Apperception and possession of his face-object consigned him to his doom. But an etymological approach to the myth suggests yet other interpretations. As McLuhan recalls, the word 'narcissus' comes from *narkôsis*, meaning 'torpor' or 'disaster'. According to the author of *Understanding Media*:

> The youth Narcissus mistook his own reflection in the water for another person. This extension of himself by mirror numbed his perceptions until he became the servo-mechanism of his own extended or repeated image. [. . .]

The Apparelled Face

He was numb. He had adapted to his extension of himself and had become a closed system.[59]

For McLuhan, what is of interest in this myth 'is the fact that men at once become fascinated by any extension of themselves in any material other than themselves'.[60] Meaning that the interpretation of the Narcissus myth in terms of self-love only goes to illustrate the orientation of our culture: intensely technological and consequently narcotic.[61] In general, McLuhan believed that myths, and Greek myths in particular, illustrate in a single image the way in which extensions of our senses serve to transform our perceptions. Thus he analyses the Gorgon myth as an account of the appearance of a writing that fixes knowledge, and the Cadmus myth as a parable of the effects of the alphabet, creator of alignments (the dragon's teeth) and new forms of warfare.[62] Likewise, the Narcissus myth may be interpreted as the expression of the effect of media upon our nervous system. According to McLuhan, we are initially incapable of recognizing ourselves in our extensions. Narcissus contemplates his image in the water without recognizing himself, for such is the hypnotic effect of media: they plunge us into another dream.

Like Benjamin before him, McLuhan noted that the effects of technics upon the social world are at first subliminal or phantasmagorical, and produce a collective unconscious or dream state. In extending one of our senses or body parts, media cast the remainder of our perceptions into darkness. If all inventions and technologies are extensions or, as McLuhan puts it, 'self-amputations' of our bodies, then clothes extend the skin, the wheel extends the foot, just as the reflected image is an extension of the self. Now, these extensions call for the negotiation of a new balance between

the organs, and McLuhan suggests that our nervous system can only cope with this kind of amplification by *numbing* or blocking perception. Biologically speaking, the human organism seeks to maintain itself in homeostasis. Everything that perturbs its balance may be perceived as a shock to the system. Inspired by the work of physiologists and neurologists Hans Selye and Adolphe Jonas on stress, McLuhan puts forward the general theory that, to protect itself, our nervous system reacts with a self-numbing or 'counter-irritant' action on a part of itself.[63] Two reactions are then possible: anaesthesia or absorption, whence the permanent stupor – in the sense of a numbness but also the grip of fascination – that takes hold in the encounter with one's externalized face.

According to McLuhan, to see, perceive, or use an extension of oneself still involves submitting oneself to it. From radio to the printed page to the screens of computers, every action implies its own logic of contamination, as we 'accept these extensions of ourselves into our personal system and [. . .] undergo the "closure" or displacement of perception that follows automatically'.[64] The phenomenotechnical construction examined above is an illustration of this hypothesis. Where film photography had produced a technical imaginary of the mechanized face wherein the face found itself *binarized, standardized, and Taylorized*, the digital, with its own particular mode of existence, will remodel the nervous system in ways that remain to be analysed. In submitting ourselves to technologies, we become 'servomechanisms' – that is to say, we adhere to what they connote in the imaginary. This explains the Greeks' suspicion of mirrors, but also our contemporaries' suspicion of new algorithmic forms of profiling. These apparatuses autonomously play on perception

and sensibility and, by affecting cognitive processes and singularity, transform them.

Although it may well indicate a certain anguish, this narcissistic narcosis is not tragic in nature. Rather, it is the index of an archaic attitude which, because it is not understood as such, tends to *return*. Whence McLuhan's methodological justification: quoting a work on economic depression, he emphasizes that there is another factor that can help to overcome crises, namely endowing oneself with 'a better understanding of their development'.[65] To immerse the face once more in the process through which it developed, to come to grips with this process, to glimpse the face's default of origin and its technical genesis may, in the last analysis, be the only way to deal with today's issues of selfomania.

Rather than ceding to a discourse of narcissism and egoism, it is important to realize how the face and its everyday mode of appearance have no equivalent in the history of humanity and of civilization. As argued by Leroi-Gourhan, this process of exteriorization and reciprocal interiorization that lies at the origin of the face and of anthropogenesis can be understood as a liberation from biological servitude, but humans have also become, as McLuhan indicates, 'the sex organs of the machine world, as the bee of the plant world, enabling it to fecundate and to evolve ever new forms'.[66] Hence this liberation can also be conceived of as loss or proletarianization. The face is produced only by enchaining itself to the technics that exteriorize it, thus rendering them more autonomous and rendering us more dependent on their functioning, practices, beliefs, and imaginaries. From prosthesis to camera, the mask as revisited in the postmodern epoch testifies to the permanent *stupor* brought about by this exteriorization. The crisis of the metaphysics of the subject that emerged during the

twentieth century, and which among artists often took the form of the series and the masquerade, is ultimately only a fundamental repetition of this traumatic origin. Freud regarded repetition as carrying an unconscious charge that was realized in the act of transference. The repetition proper to memory appeared to offer a curative protocol, since remembering allowed the subject access to the episodes of its history repressed by self-defence mechanisms.

4
The Space of Appearances

Prior to being thought of as a popularization leading to effects of saturation and reification, where the only recognition left is that of a police record that reduces the subject to a statistical aggregate, the democratization of the face enabled by photography had opened up unprecedented possibilities for the writing of the self and for techniques of the self, as well as calling identity categories into question. But it had also activated a scene of appearance where, suddenly, a 'politics of the common' could be negotiated that redrafted the contours of our being-together. As a condition of the 'bringing to light' of this politics, photography played a part in the political legitimation of individuals. By opening up a supplementary space made up of images, the face-image participated in the establishing of modern democracies by allowing an articulation of politics and the political: power through representation, and representation as *common space*. Photography delimited a *space of exposure* in which more or less coded gazes and subjectivities intersected and negotiated. Thus it situated itself in an intermediary space between the private and the public; it rendered visible a face which,

without its image, could not 'appear' on the public scene.

The Spectacle of Politics

The invention of the political in Ancient Greece corresponded to the opening up of a new space, a space in which men acted and interacted, and entered into face-to-face *relation*. By delimiting spaces of *projection* such as the agora or the theatre, Antiquity rendered public what had until then remained the province of the sacred: the *politeia* became a public thing, a *res publica*. Manifesting both their unity and the community that bonded them, men called forth a space of appearances or of appearing through which action and speech could be organized.[1] Hannah Arendt defined this space of appearing as 'the space where I appear to others as others appear to me, where men exist not merely like other living or inanimate things but make their appearance explicitly'.[2] From this there emerged a new distribution of the visible in which individuals, qua autonomous singularities, would be free to act and to speak out, even if this distribution involved a necessary fiction. Thus political life had to be equipped with an 'apparel' [*appareillage*] in which vision, ultimately, would play a primary role. What the political apparatus had in common with the photographic apparatus, the *camera obscura*, and the psychoanalytical cure, as well as perspective and Benjamin's passages, was that they were projective and were configured in terms of representation. Photography and cinema would soon have a new surface of inscription at their disposal: the community.

Although Arendt criticized the assimilation of technics into the human, her conception of politics is

revealing of what a face, understood as interface, *can do*. Politics, Arendt writes, 'arises *between men*, and so quite *outside* of *man*'.[3] Whereas Arendt postulated that this space was neutral and naked, receiving indifferently and immediately all those who expose themselves to it, Jean-Louis Déotte emphasizes that we need to think the technically augmented [*appareillées*] conditions of possibility of being-together. In his Benjaminian reading of the political in Arendt, Déotte points out that political action is inseparable from its *spectacularization*, adding that 'the political *we* is topologically *augmented* [*appareillé*]';[4] it is a common ground that circumscribes a space of representations in which multiple points of view converge and within which grand narratives and a shared mythology take shape. According to Arendt once again, it is human *plurality*, in the twofold sense of equality and difference, that is the condition sine qua non of politics. Plurality cannot be reduced to the mere proliferation of the same model, otherwise there would be no place for action. It is therefore *separation that binds*, and the capacity to form bonds across and on the basis of division. In this sense, the sudden irruption of crowds as dense and formless aggregates is not in itself political. Only when the anonymous recede can political action develop, an action formulated in terms of appearance, in the sense that makes it possible to give to others an appearance, a singularity – in a word, a *face* to which a voice can be attached.

With the emergence of the great metropolises, demographic growth, and the multiplication of flows, it became necessary to make bodies and identities visible in order for knowledge and power to be exercised upon them. If the enterprise of facialization established in the nineteenth century was despotic in nature, ceaselessly coding and imposing a 'type' or 'facies', offering

individuals the illusion that they could constitute themselves as autonomous subjects, it first of all constituted a system for the production of 'objective' images suitable for the elaboration of a new positivistic conception of man. Indeed, as Foucault emphasized, 'there will be no science of man unless we examine the way in which individuals or groups represent to themselves the partners with whom they produce or exchange'.[5] The mass arts of photography and cinema accentuated homogenization since, like totalitarian regimes, they depended upon what Levinas called an 'ideal of fusion' in which the individual is 'immers[ed] in collective representation, a common ideal or a common action'.[6] But in democratizing the portrait and placing it in circulation, these techniques would also allow the masses to be 'brought face to face with themselves'.[7] The production of images and their materiality within the public space sketched out the contours of new scenes of representation.

Pursuing Heidegger's intuitions on *mitsein* or being-with, at a certain point Jean-Luc Nancy developed the idea of a scene understood as the 'space of co-appearance [*com-parution*]'.[8] 'Co-appearance' means not only that subjects *appear together*, but also that they appear according to a shared, 'simultaneous' temporality.[9] Co-appearance as a concept of being-together thus consists in appearing both to oneself *and* to one another within the same temporality. This is why there can be no 'naked presence' of the community without an *originary mimesis* – that is to say, without appearances, without spectacle. It is also the reason why presence is always at stake in re-presentation, and why aesthetics is fundamentally political. At least we must say that, if every community is instituted in a certain form, this form must be capable of alteration, of differing from itself, freeing itself.

The Space of Appearances

The Face of the Collective: Relation or Rapport?

The question of a collective governed by common action becomes increasingly problematic as our modes of interaction become more complex and diverse. Individuals' continuous observation of themselves has transformed a great many of us into both subjects and objects of surveillance and attention. Antiquity had its theatre; our societies have a differently augmented [*appareillée*] space that produces its own temporality and spatiality. Think of the self-portraits and self-fictions that inundate social networks, blogs, and other image-sharing sites such as Snapchat, YouTube, Instagram, Facebook, or Tinder: they all combine to disqualify being in favour of a scene of appearance that fosters publicity and easy seduction. The importance of this autocentric and self-referential dimension appears to index society's increasing incapacity to think alterity, mediation, and, even more so, reason and common action. Even if spectacularization is a condition of possibility for politics – an assumption that leads Nancy and Déotte to criticize the approach of the situationists, for example – we are still within our rights to query the legitimacy of these processes within the cultural industries, and the algorithmic organization of visibility on the Internet according to statistics, likes, and comments.

In an all-seeing digitized world in which panopticism has been extended to a global scale, transforming the real into images and the face into an image of images, we slide from *relation* – proper to the face and to politics – into the mode of *connection* – the sphere of publicity and currency. The selfie, as an interface between myself and the other, the intimate and the extimate, the inside and the outside, is the site of a mediated intimacy, closely linking that which is most profound with that

which comes to the surface in the public domain. So self-ies exemplify the twofold nature of the interface in so far as they are situated between the private and the public and require a technical interface in order to appear.

If progress in communications seems to have favoured impersonal forms of relation in which anonymity replaces direct face-to-face contact, it seems that new possibilities for interaction and co-participation have also emerged. Today more than ever before, faces, and selfies in particular, are animated by a demand for inter-action and communication, contrary to what the word 'selfie' tends to suggest. The conversational dimension of selfies enhanced with hashtags or emoticons brings with it a logic of references and allusions specific to cer-tain communities, allowing these communities to appear to themselves and to others.

When an amendment to France's proposed health law of 2015 suggested a fine of 10,000 euros and up to a year in prison for young anorexic girls who publish content on Instagram under the hashtags #AnaBeat, #AnorexiaRecovery, #FuckAna, #AnaBitch, #AnaWarrior, or #AnaFamily, a series of articles protested that the authorities did not understand the benefits for this community in finding paths to recov-ery through a network of mutual aid outside of the medical arena. Certainly, the compounding of these young girls' addictions by a dependency on likes may have attenuated any such benefits, and yet when they were made public, the girls became political subjects. The same goes for the communities of young mothers, professional and amateur sportswomen, and trans and other minorities, whose continuous self-documentation and innumerable selfies provide a means for them to appropriate an identity under construction, to mutually support one another, and to proudly share their transi-

tion. Because they have been displaced and are now visible, the old divisions between private and public that founded political legitimacy are open to debate. These new modes of indexing give us faces whose geography and fate are tied to those of the network community. Within these lifestyle, hobby, or belief communities, we perceive the presence of a conscious participation in the public thing, the *res publica*. As Déotte remarks, exposure is 'always exposure to a public, which is therefore not that which exposes itself. There is always a minimal gap between oneself and that which registers one's trace, the archive.'[10] The staging of communities on networks testifies to this trace, rendering these communities visible to all. Frédéric Neyrat adds: 'There is no political community without an aesthetic institution – without a sculpting of the collective body, without political technics.'[11] If the intimate passes via the other, and if therefore the intimate requires interaction, then it makes perfect sense to position oneself in the path of this gaze directed toward the other, and toward the *territories* of their intimacy.

The Politics of Publicity

Avatars, digital profiles, and other selfies are cultivated for their indexical nature, becoming vectors of identification for 'e-putation' and the logic of 'personal branding' that shapes contemporary forms of social recognition. If this suggests a pronounced tendency toward publicity, it is first and foremost because publicity is that which links us to public space – literally the 'act of making public' or 'the state of that which is public'. From Facebook to YouTube, the space of the Internet is a public arena, a public stage upon which publicity becomes a resonant *mouthpiece*, as in the Latin *per/sona*. From the politician

to the star, from the terrorist to the selfie amateur, each *assumes* their aesthetic and political responsibility in terms of appearance. Society, along with its systems and algorithms, therefore provides the framework within which, in socializing themselves, individuals produce themselves via their daily use of these technologies. Facebook and Instagram – which, let us not forget, are primarily businesses – have become allegories for the immaterial labour that serves to construct our being-together. Providing a platform for production founded on participation and co-creation, our societies tend to become indistinguishable from the work of the production of singularities and collectivities. So the frenetic diffusion of selfies can be said to at once produce 'raw materials' for these businesses and fuel the industries of singularity. Each and every person has become a content producer, and therefore both the *actor* and the *work* of what they themselves publish and communicate about themselves. And this is where the problem of the exploitation of this 'selfic' content arises.

For a long time now, Olivier Ertzscheid writes, 'man has become a document like any other', and no longer has an 'identity of which he is the proprietor'.[12] But unlike the bourgeois face, contemporary individuals increasingly manage their visibility, and only modestly underestimate its commoditized nature. So that what is at stake today is investment in the possibility of raising oneself above the normative tendencies of the digital economy, by affirming oneself as a power of *becoming*, not just the result of a mass of preselected data. Between *praxis* and *poïesis*, it is the *performative* and *creative* dimension of online faces that dictates our subjection or non-subjection to current technologies. It is therefore now a matter of making use of the dispossessing power of algorithms, likes, buzz, and comments to 'sculpt one-

self'; it is up to everyone to *appropriate* this common culture *for themselves* by subjectivizing it.

Contemporary faces, then, do not offer themselves up as spectacle; rather, they demand spectacle, their passivity rivalled only by the presupposed passivity of those looking on from behind the screen. Without this continuous surveillance, the vision of these faces would be lost in the flux of images. Whereas in *A Thousand Plateaus*, written in 1980, the authors distinguish moulding from 'modulation' (a moulding that acts internally and through temporal transformation), by the time of 1990's 'Postscript on Control Societies' this modulation has become the instrument of a continuous control immanent in the social body.[13] When the injunction of visibility gives way to the imperative to see and be seen, subjects are no longer the victims of discipline, but the permanent actors of their own autopositioning within the aesthetic field. For the contemporary subject has imposed a new obligation upon itself: that of 'self-design, an aesthetic presentation as ethical subject';[14] and self-ornamentation is no longer so much a matter of an economic context as a political one, as we can see in the debate over the Islamic veil. Design is practised as a production of differences that implies a political semantics – so that, if the logic of capital places the subject and the myth of interiority at a distance in order to better function, this presumed desubjectivation must be understood as a multiple participation in the world, allowing access to the collective and political environment. In this way, social space is transformed into an exhibition space, and, like every other object of circulation, like all commodities, the face enters into a circuit of exchange value. Now, according to Emanuele Coccia, in the opening page of his book *Goods*:

Commodities are the flashiest residents of our cities: they reign from those little street temples for hurried passers-by, store windows; they paper the most visible walls of the busiest neighborhoods; they cover every inch of a city's surface, delineating the real boundaries of civilization. [. . .] "Commodity" is the most common and general metaphysical heading for the category of the object, its most common synonym: to come into the world as a thing, to be one of the things of the world, it seems necessary to be or to be capable of becoming a commodity.[15]

To see the commodity as *ignominious*, to allow the reasons that drive us to deny and unreservedly reject it to blind us to its real qualities, is to forget that, above all else, it presents us with 'the extreme form of the good, the most recent name Western culture has given to the good'.[16] As Coccia remarks, commodities are shown in pride of place on the *walls* of our cities. These walls, which delimited political communities, functioning via inclusion and exclusion, were also *surfaces* upon which those communities could project and leave behind the marks of their own portrait, like the Facebook 'wall' whose timeline we scroll down and whose surface 'won't stop making itself seen, communicating its own image, and talking about itself'.[17] The walls of cities are the memory and the consciousness of that which is reflected in them; it is through them that the *moral gaze* and a *politics of the common* were formed, as they welcomed gods, then heroes, then politicians, those who revolted, propagandists, and now the most trivial things of everyday life, including 'shampoos, telephones, perfumes, records, bras, chocolate, meat – all the things that, simply, we call commodities'.[18]

For Coccia, the replacement of the great accumulation of divinities and glories by images of consumption

is not at all alienating or morally disreputable. Our civilization's obsession with the object has transformed these commodities into *politically perceived symbols* via advertising and publicity, which therefore should not be understood as mere packaging to drive consumption. If to the question 'What is art?' Baudelaire responded 'prostitution' when it is driven by the desire to please, and if 'the artist of modern life was he who was ready to accept the condition of prostituting his practice',[19] prompting Laurent de Sutter to affirm that 'every artist is a whore',[20] then in becoming the artist of their lives, both author and product of their self-design, everyone today is a 'whore' cultivating their public image, and publicity is their ornament – that is to say, a form of collective dreaming that provides them with a symbolic double.

The Mass Ornament

In his book *The Mass Ornament*, written in the 1920s, Siegfried Kracauer analysed emergent cultural forms from a perspective very different to that adopted by his Frankfurt School colleagues Adorno and Horkheimer.[21] Kracauer did not cleave to a discourse of catastrophe that saw mass culture as decadence. Conscious of the ambiguity of such systems, he presented a more dialectical critique, laying out the premises of a politics within what today we call the 'cultural sphere'. Following the interactionist method of his teacher Georg Simmel, without defining it as such, Kracauer based his thinking on the notion of the *milieu*. Like Benjamin, he was fascinated by the world of passages and the figure of the flâneur. It was therefore the specific technicity of augmentations [*appareils*] that interested him. He characterized his method as a 'construction in the material

of history'[22] which sought to penetrate the real on the basis of its *discrete surface manifestations*, and accordingly paid tremendous attention to imperceptible details and signals. Neon signs, hotel lobbies, ballets, and gymnastics constituted a raw material from which one could construct a network of analogies between things. Kracauer developed a *hermeneutics of surfaces*, using these surfaces to traverse reality and to critique it. This space of appearances was conceived as the 'extension' of architecture, with sign privileged over forms, communication over the structuring of space. Analysing the way in which bodies were instrumentalized in certain spectacles such as the dance troupe the Tiller Girls, Kracauer defined mass ornament as 'the aesthetic reflex of the rationality to which the prevailing economic system aspires';[23] in the image of Fordism, the mechanization of the girls' limbs corresponded to the grammatization of the factory. The mimetic and repetitive structure of this ornamental aesthetic was an abstraction devoid of all substance and singularity, tending toward an absolutism in which it would designate only itself. The formalist exigency of the modern era, become its own reflection, resonates with the self-design of our contemporary societies – both respond to the 'aestheticization of politics' examined by Benjamin. Similarly, it offers an anticipatory echo of the fears expressed by Nancy, for whom ultimately 'co-appearance might only be another name for capital',[24] in so far as it posits a set of individuals as indifferent and interchangeable particularities.

But Kracauer did not reject these ornamental forms; according to him, they could not be dismissed as mere acephalic distractions. As he explains: 'No matter how low one gauges the value of the mass ornament, its degree of reality is still higher than that of artistic productions which cultivate outdated noble sentiments in obsolete

forms – even if it means nothing more than that.'[25] To him the category of exteriority seems preferable to that of an aesthetic founded upon the idea of 'interiority' or 'personality'. Distancing himself from a romantic vision, he sees *calculating reason* as playing a fundamental role in the process of demythification. If capitalism is too often reproached for a rationalism that condemns the human to servitude, Kracauer believed that capitalism 'rationalizes not too much but rather *too little*'.[26] A reader of Marx, he provocatively wagers that a surplus of rationality will lead *the spirit of capitalism* to turn against itself – in doing so anticipating Alex Williams and Nick Srnicek's 'Accelerationist Manifesto'.[27]

The significance of these aimless ornaments, he adds, lies in their properly anti-natural and inorganic character. The non-organic emerges out of the organic, paradoxically opening the way to its surpassing, and even to new ways of understanding life. This departure from the natural and biological framework, however, would not go astray into the totalitarianism of the Italian Futurists, with their aspirations to be absorbed into the flux. Certainly, like the 'body without organs', it called into question the individuality of their members, but at the same time it destroyed the illusion that individuality was a given that found its culmination in the organism and in substance. This is precisely the critique of the hylomorphic schema and of substance that would later permit Gilbert Simondon to think individua*tion* as a process and as a principle of transduction with an associated milieu. It favours a thinking of the event in which the human is freed from its biological substrate.

For Kracauer, then, the utopian promise of these geometrical formations can be attributed to their very rationality. Notwithstanding their mechanization, anonymity, and massifying effects, they heralded

a desubstantialization of nature which, in spite of the risks it involved, implied a radical historicity of humans. We must recognize both the radicality of his critique of technical rationalization and the paths it opens up for a 'politics of rhythm', in doing so coming close to presenting a vision of post-capitalism. There is an emancipatory promise in this ability to follow the movements of the world, to come out of one's self even while remaining within it. In other words, rather than fleeing this reality or returning to mythology, according to Kracauer we must *go all the way through disenchantment in order that, in the end, a reconstruction can be envisaged.* 'The process leads directly through the center of the mass ornament, not away from it. It can move forward only when thinking circumscribes nature and produces man as he is constituted by reason. Then society will change.'[28] The rationality of the mass ornament is, then, a reduction of the natural that 'does not allow man to wither away, but that, on the contrary, were it only carried through to the end, would reveal man's most essential element in all its purity'.[29]

From the Mass to the Multitudes

The human figure 'enlisted in the mass ornament has begun the *exodus* from lush organic splendor and the constitution of individuality toward the realm of anonymity to which it relinquishes itself when it stands in truth'.[30] The mass ornament was inseparable from a 'mass subject', which explained why life itself and social relations took on the traits of the ornament. From this epoch onward, observes Christine Buci-Glucksmann, 'the mass subject is auto-ornamental',[31] and the effect of this was to engender a new narcissism on the basis of a

subjectivity that was fragmented, folded and unfolded, and which opened onto other possibilities. Going to the very end, to the end of the deracination and relativization characteristic of modernity, Kracauer defended these new forms of culture which, for him, had the merit of *sincerity*, and consequently went in the direction of *truth*. As he sets out in his article 'Cult of Distraction', this vitality was threatened by

> [t]he naïve affirmation of cultural values that have become irreal and by the careless misuse of concepts such as *personality*, *inwardness*, *tragedy*, and so on – terms that in themselves certainly refer to lofty ideas but that have lost much of their scope along with their supporting foundations.[32]

Here Kracauer prophetically defined the contemporary subject, of which the selfie, lying in wait behind stereotypes and ornament, is the paragon. But he also designated the chiasm through which the production of sincerity now passes via a *supplement*, to which we desperately attach the existential categories of profundity. Here we find the restoration of a *topos* of the contemporary whose political flipside is the headlong rush of the existential subject into new processes of subjectivation. The mass ornament is now transformed into a creative ornament; the ornament of contemporary societies produces a culture of surfaces and objects of a new type, surfaces across which there circulate a raft of informational, commercial, and human data. According to Buci-Glucksmann, it is no longer a matter of 'marginal and discrete domains of the culture of surfaces, but of a whole, increasingly globalized society, where fluxes become forms, albeit those of an organized chaos'.[33] Today the generalization of these spectacle-forms affects all beings, all things. Subjectivation itself

has been spectacularized; it has become the product of a self-ornamentation in which anonymous singularities are self-organized and co-activated and, as such, are opposed to formless and passive masses understood as an 'indefinite multiplication of individuals'. The *vita contemplativa* is succeeded by the *vita activa*. This is why Toni Negri and Michael Hardt, rather than continuing to speak of 'masses' or 'classes', replace these terms with that of 'multitudes'.[34] By broadening the space of appearances to include the sphere of screens, blogs, and other sites of self-publicity, the network has rendered possible anonymous multiplicities and singularities that would otherwise never have been encountered. Publicity thus plays the role of an operator of individualization in so far as, in publicity, according to Coccia, 'it does not talk in general about skirts or shoes, but about *this* skirt and *this* shoe'.[35] In relation to the crowd, publicity conserves the singularity of its members even as it develops within a collectivity. This digital transformation of the human community is radical because it touches on our very experience of anonymous multitudes without our fusing with them. In virtue of this – and not without a certain cruelty – it seems that *plurality* is conserved.

If being-in-common cannot be thought either as a multiplicity of ones or as a constitutive unity but only as a between-two, that is to say, as *relation*, as coexistence or 'co-appearance', today this distribution of the 'with' is exhibited as *connection*, as spectacle and publicity, but above all as *infinity and milieu*. Ultimately the problem comes down to constructing a form, that is to say, a community, in a context without limits, 'outside of all measure'. Now, '[e]cotechnics might be the last figure without figure of the world's slow drift into sovereignty without sovereignty, into finishing

without end'.[36] *Ecotechnics* is the name of a 'political economy' in so far as, when *oïkos* is everywhere, *polis* no longer exists. But ecotechnics is also the result of the twofold regulative principle of our societies: the 'world-economy' and 'planetary technics'. Ultimately, '[w]ith a certain obscurity and ambivalence, the global world of ecotechnics itself definitively proposes the thoroughgoing execution of sovereignty. "Thoroughgoing" here means: going to the extreme, of its logic and movement.'[37]

Here we rediscover the force of Kracauer's critique, along with that of the accelerationists, who, seeking to go to the very end of things, gesture toward an overflowing. By transforming the world into a network of images transited by fluxes and human capital, the face has entered into a mediated economy of fluxes. If man has fashioned a meshwork of images referring to other images, if the human has itself become a commodity, it is indeed because without images, without the sensible, there would be nothing but

> a universe where things and forms would no longer be capable of living outside of themselves in order to reach living beings, and thus live – in intentional form – within them, influencing their every movement, [a universe that] would lose any consistency whatsoever. This universe would become a mass of petrified reality. [. . .] The connective fabric between things is produced by *media*, which represent the condition of the possibility for the existence of the sensible.[38]

The democratization of anonymous faces via techniques of reproduction has allowed these faces to enter the mediological terrain 'of codes, of artifices, and of technical interfaces'.[39] Because the contemporary face is an interface upon which there play out a *praxis* (action) and

a *poïesis* (creation), obliging us constantly to produce *ourselves* and to interact, it can be considered as an everyday practice, whose political economy ought to be analysed and critiqued.

5
Critique of the Political Economy of Faces

Just as the commodity is both use value and exchange value, so the contemporary face has entered into an economy of fluxes wherein its mode of appearance is the product of an eco-technical system. Selfies, as augmented [*appareillée*] interface, territory, and subject, express the visage of a collective documenting itself in real time. In this sense, the practice of online self-portraiture constitutes one possible response to the masses' difficulties in appearing *to themselves*. Lit up like fireflies, each with its own light, no longer levelled by a unidirectional projector, the masses are no longer undifferentiated, but emerge from a composite *plurality* of auto-ornamental singularities. The multitude has turned the camera on itself. Between living document and technique of the self, between art and artless, the selfie constructs reality out of 'social facts' and constitutes itself as a heuristic function. But this raises the question of the value of the faces of this anonymous multitude, freely accessible on the network: Is this a new form of 'voluntary servitude' in the service of the industrial production of singularities? Or does the multitudes' self-representation as ornament and as

publicity establish an art of individual and collective self-care?

From the 'Self' to the Relational

The appearance of photography in the nascent metropolis went along with the desire and the need to *see* and to *have* a face. Certainly, this face was the one that circulated on railways, the criminal in flight who had to be identified, the hysterical woman who needed to be 'calmed down' before she could be freed, but it was above all that of a bourgeois class whose actors found themselves in the advance guard of the Industrial Revolution. Merchants, factory owners, boutique owners, scientists and liberal professionals, entrepreneurs and accumulators of capital, all organized their private life in the same way as they managed their *properties*. As Jeremy Rifkin writes, 'Every aspect of their being was enclosed, privatized, controlled, bounded, categorized, protected, hoarded, and hidden away from public scrutiny. [. . .] The interiorization of physical life was accompanied by the internalization of consciousness.'[1] If the face set the rhythm for the everyday, with new portraits taken as frequently as wallpaper was replaced, between the identity of person and place there was a relation of reciprocal domesticity. The bourgeois class cultivated its intimacy in the shelter of its shops and its salons, and the English-speaking world was full of talk of 'self-confidence', 'self-love', 'self-pity', 'self-esteem', and 'self-worth', as Rifkin documents. The *self* was the object of an obsessional preoccupation that reassured it both of itself and of its *private property*. The latter certainly contributed to social development, just as it was a manifest sign of an extension of the personality: the possessed object became an extension of identity. To

have one's portrait reinforced the twofold jeopardy of the subject and its subjection. It was at once the manifest sign of an individuality and the extension of this latter, even while it had to respond to 'combinations of units', as Deleuze and Guattari would say, meticulously compartmentalized, 'landscapified'. For each 'faciality' was enveloped in the landscape of work, the landscape of worldliness, or the landscape of filiation; and in so being, was assigned to a residence, classed, surveilled, and controlled. This meant that the faciality of industrial capitalism was indeed the product of a form of social and eco-technical organization that individualized, expressed a function, and placed the subject in an 'identitarian fold'. Social norms and determinations – the worker, the bourgeois, the son, along with the woman, the monster, or the foreigner – were erected according to a logic of representation whose aim was the subjectivation of individuals, as the traditional mass media (photography and cinema) ceaselessly diffused and indeed amplified these models that referred the mass to an entirely 'coded' face.

This should, then, prompt us to interrogate the movement from an economy founded on property and large-scale production to an economy founded on immaterial forms of investments and renewables – that is to say, on the accumulation of knowledge, creativity, and the logic of access. If, as Rifkin argues, the 'ego' disintegrates as the notion of private property weakens, then what does this imply for individuals living in a connected world where every day a network of shared, globalized images is constructed? In freeing themselves from possessions in favour of an economy of 'network access', do contemporary individuals turn away from the *self* and their house-arrest and take on instead a new, relational force?

Critique of the Political Economy of Faces

Whatever the terminology or the approach taken, the progressive movement from an industrial capitalism to an economy of contribution and creativity, as outlined, successively or concomitantly, in the notions of 'late' capitalism (Jameson), 'cultural' capital (Rifkin), and 'cognitive' capitalism,[2] and the supposed 'knowledge economy', implies a profound change in behaviours *and* in the cultural regime that now extends, in vernacular manner, throughout the entire social field. In parallel with these upheavals, the web has turned from a *web of documents* into a *web of people*, also known as 'Web 2.0'. This 'profile web'[3] is evolving in real time, organized by users' metadata, while faces and avatars continue to 'dress up' the flows[4] – that is, to polarize and canalize its hyperlink logic.

In networks, the notion of *access* replaces that of *property* and, by extension, that of stability and interiority. If from this point on we are no longer involved in the management of physical goods but only that of services, if the value or status of a person is no longer measured by the extent of their material patrimony but by their propensity for connection and availability, then there has been a displacement from the interior toward the exterior, from accumulation toward dispersion. In other words, identity depends less upon the volume of what is produced and accumulated by the individual than on the relations of intensity of the experiences to which they have access. Online self-portraits have become just another type of content, driving a permanent process of self-documentation founded not so much on a principle of utility or exchange value as on the emotions they may elicit. In the age of access, the face we share on certain networks and which serves us as a point of entry into others and into the world has to be continually reproduced, valorized, aestheticized,

actualized, and augmented in order to ensure that it remains viable and competitive. Today, therefore, it is the practices of individuals – since they are now not only *authors* and *works*, but also *actors* and *curators* of their own lives – that determine the exchange value of faces. Whereas industrial capitalism tended to strip individuals of their knowhow by submitting them automaton-like to the division of labour, the new economy exploits individuals' libido and the leisure activities (such as sport, theatre, or cultural experiences) on the basis of which they develop the capacities for improvisation, creation, and cooperation, of which selfies are the consummate incarnation. As capital penetrates and mobilizes consciousnesses, it produces a subjective plasticity that escapes in every direction. On the one hand, this obliges control to itself become nomadic and to discover other strategies, modulable and capable of *action at a distance* – via smartphone apps, for example. On the other hand, it constrains individuals to subjectivate themselves through the industries of singularity and the ideology of entertainment.

Now, this original self-production that each person carries out 'outside of and upstream of remunerated work', and which renders them capable of interacting, communicating, learning, and evaluating, 'plays a role comparable to that of "surplus labour" from the moment when it is "put to work" in the production of value'.[5] This value is further fuelled by the figure of the amateur who posts his or her meals, travels, and selfies in virtual galleries. The amateur thus becomes the *ideal type* in the economy of contribution, participating in the construction of a common world via the sharing of intimate and consciously categorized imagery, while through 'this shared *meaning*, to which all subscribe, everyone knows what they must do without having to be told'.[6] And so

there is no longer any use for a *leader*, as Luc Boltanski and Eve Chiapello suggest, but only for *influencers*, like the fashion bloggers or young YouTubers whose faces have become brands. Here we see the self-organization of a plan for voluntary servitude to the industries of singularity, in which selfies have become the mirror of a hardworking multitude that produces a 'we' by each designing their 'me'.

And yet this would be to forget that Max Weber, in *The Protestant Ethic and the Spirit of Capitalism*, insisted that a set of shared beliefs tends to promote a certain individualist ideology which pushes each individual to see *in the maximal exploitation of themselves the expression not of their subordination but of their liberty*. Even if they exhibit all the features of an inflated and stereotyped libido, selfies nonetheless permit us to think a production of subjectivity or *constitutive ontology* of an entirely new order. For, according to Foucault, techniques of the self are dependent upon certain characteristics: they arise out of regular, repeated, and even ritualized practices. But, above all, *care of the self* is also a *government of the self and of others*, to be understood as *creation* and *care*. In their relation to forms of editing and curation, these practices testify at once to that which *one must take care of* and *that to which one must pay attention*. For selfies set out from images that are utilitarian in nature and belong to an act of communication, but which end up crystallizing into an imaginary that is foundational for tomorrow's symbolic reality.

#Selfie: A Contemporary Readymade?

Well before the many twists and turns of the case of American artist Richard Prince's recuperated selfies, the Catalan artist and theorist Joan Fontcuberta had

drawn attention to these amateur practices by way of what at the time he called 'reflectograms'. This was in 2011, before the term 'selfie' had been enthroned in the *Oxford English Dictionary*, but Fontcuberta already realized how freely accessible online self-portraits offered an unprecedented sociological vision of our society. Although a great many of these images testified to a click-frenzy that was far from the ceremonial and evental character of photography as examined by Pierre Bourdieu in *A Middlebrow Art*,[7] they were nevertheless founded in commonplaces, and were full of eroticism, *pathos*, and basic sentiments. Social uses of the digital image, capturing and diffusing the everyday environment, would only become more widespread. The result would be banality twice over: of the photograph and of photography – a banality levelling images and their quality.

The institutionalization of amateur practices in the exhibitions *Tous photographs!* (Lausanne, 2007), *From Here Now* (curated by Joan Fontcuberta at the Rencontres d'Arles photography festival in 2011), and, more recently, *From Selfie to Self-Expression* (Saatchi Gallery, London, 2017) exemplifies the interest in images that are supposedly 'without qualities'. These exhibitions attest to the recognition of these 'minor' art-forms, as well as the compelling economic strategy of the face. Bringing together works ranging from Rembrandt to Kim Kardashian's selfies, by way of Andy Warhol, Tracey Emin, and Cindy Sherman, the Saatchi Gallery, in collaboration with Chinese telecommunications giant Huawei, organized an open contest for amateurs under the hashtag #SaatchiSelfie – in doing so reproducing, rather unoriginally, the marketing strategy of Samsung at the 86th Oscars Ceremony. The capital visibility of faces, once reserved for stars, politicians, and terrorists,

is now a tool for everyone. Within this all-encompassing consumerist circulation, where individuals are what they are because they are inscribed in a certified systematic reproduction process, they demand validation via attention. Before being a propaganda strategy, publicity is a form of mass communication whose sole aim is to capture an audience's attention. It 'mystifies consciousnesses by mythifying commodities, so as to give them an *aura* without which they would appear just as they are, dull and industrial'.[8] In doing so, it signals a community, a 'spirit', implying the participation and adhesion of individuals.

Selfies are by definition part of a logic of overflowing, of surplus. Hyper-exposed, hyper-sexualized, outrageously mediated, they respond to a twofold constraint: that of buzz and that of a scopic drive pushed to the point of intoxication. The selfie is at once the reflection of an individuality and of a collective, the underside and the other side of an overexposed intimacy lived out every day as that which is most deep and most superficial in the self. The selfie is thus a royal road of access to personal mythologies and popular phantasms. 'Selfie-porn', in the same sense as 'food porn' or 'ruins porn', relates to a form of spectacle where voyeurism and its exploitation depend on a media ecology – that is to say, on a technical milieu (an environment, an interface, a territory) that determines what we will pay attention to. Selfies are therefore central to an attentional system that measures an individual's degree of existence by the quantity and quality of perceptions of which they are the object.

Richard Prince's 'Appropriation Art' consists in 're-photographing' existing photographs as if they were his own creations, as in the celebrated series of cowboys from the Marlboro advertising campaign. With the *New*

Portraits series, a collection of postmodern readymades, 'images of images' of a world passed through the media filter, Prince's oeuvre took a new turn by immersing itself *in*, or rather allowing itself to be traversed *by*, the flux of images and of conversations between them. Moving from his interest in American pop culture toward a globalized subculture, the artist appropriated the vernacular universe of personal Instagram accounts simply by taking screen captures.

Exhibited for the first time in autumn 2014 at the Gagosian gallery on Madison Avenue, the *New Portraits* series had initially appeared, almost daily, on the artist's own Instagram account. But it was only after the series featured in the Frieze Art Fair in New York the following year that his gesture provoked media indignation. In sensationalist style, numerous press headlines described with slight variations how the images had been 'stolen', reporting on the huge sums the artist and art market were making from them.[9] This press won over readers, not unreasonably, with its insistence on the need for art to respect ethics, and its complaints that copyright had been trampled on. Prince had made only minimal formal modifications, limited to reframing and changing the format of the initial photos. But the opportunity to alert individuals to the commodity nature of their faces and their intimacy, from which only big firms such as Facebook and Instagram profit, was passed over in silence in favour of the supposed greed and cynicism of the artist. The press served up exactly what their readership expected: sex, money, the usurpation of identity. But Prince had understood better than anyone the extent to which selfies today are nothing other than publicity and, as a good 'appropriationist', had captured these photos so as to reveal their hidden dimensions.

Prince's modus operandi was simple. He first liked

and re-grammed each image, and then commented on it as if he were an intimate acquaintance of the account holder, or adorned it with emojis as eloquent as his little mischievous or risqué remarks. The screenshots were then enlarged and printed on canvas in a format exceeding 120 × 160 cm. Originally destined for the scrutinizing gazes of users on their little phone screens, the images suddenly found themselves canonized. These fuzzy pixellated 'Instagram paintings' were immortalized, escaping the vacuous flux. *New Portraits* froze that which had no finality other than to be immediately lost in the ephemera and the mass. No longer swiped away by sweaty fingers, clicked and liked, the faces recovered their nature as portraits and, along with it, a certain 'aura'. Through these 'captures', mixing on the fly images and words throughout the day, the banality of everyday lives was theatricalized, staged, and recounted. In other words, it was transfigured, like a trivial object promoted into a work of art, as in Marcel Duchamp's readymades. Freezing the image, elevating the selfie to the rank of a portrait, albeit one captured in an already fleeting instant, Prince also fixed our attention on these faces.

Instead of a latent voyeurism, our gaze became a 'joint attention',[10] which, as Yves Citton explains, following Daniel Bougnoux, is more a matter of *communion* and of *care of the community* than of the mere transfer of information implied by all communication. The attention Prince paid to certain portraits – and thus to certain people – drew the attention of others in the same direction. In spotlighting a certain image with his media torch, in making an effort at an emotional attunement without which his approach would not have been truly attentive to the other, had he established an aesthetic of attention?

The Cryptopornography of Care

Up until 2016, the image-sharing platform Instagram, unlike Facebook, did not function on an algorithmic architecture. Purchased by Facebook in 2012, the network subsequently became subject to the same principle of hierarchization, resulting in the posts with the most 'likes' being promoted. At the time when Prince began his series, the little square-format images could not be enlarged between two fingers, and simply paraded across phone screens at the rate they were being produced. No hierarchy presided over the order of their appearance, something which encouraged a sort of levelling between celebrities and anonymous users. This levelling had certainly prompted celebrities to display their everyday lives in a most intimate manner, as was the case with Kim Kardashian, who, on 28 April 2005, published *Selfish*, a 352-page book reviewing ten years of self-portraits. The pre-parameterization of attention may have been less visible on the Instagram platform, but the circular dynamic between attention and value creation was nevertheless at work in filters and indexes organized by keywords such as #selfie, #cute, #fitness, or #healthy – hashtags which reflected the trends of contemporary preoccupations with the body and its image.

But attention cannot be reduced to the question of means alone. It valorizes and, in so doing, it is individuating, in so far as it relates to the circular dynamic 'I valorize that to which I pay attention, and I pay attention to that which I value'. To produce attention is to participate in psychic *and* collective individuation by producing *bonds*. The selfie is certainly self-centred, yet it also has to be received by someone.

By 'trolling' these selfies, Prince made himself their privileged *screen*. He became medium and buffer for the

narcissistic and libidinal projections exacerbated by this 'pornography' of the selfie. He provided a screen, and an image, by reinjecting the flux of desires with fiction and temporarily détourning it. He encrypted everyday practices by taking over the flat lives of users, whose banality and superficiality remained, in their very spontaneity, the most important thing. By materializing the selfie on a canvas, by 'artifying' it, he made a work of it, just as Warhol before him had made the star's face into a consumer product.

The artist articulated the relation between the selfie and porn, as witnessed in the madness to 'see and be seen at any price' in terms of two times and two spaces: one in front of the screen, its contents moralizing or censored by the platform; the other behind the screen, in the brutality of the real and the blatant nature of drives. If intimacy has been overexposed for some years now, the question of the articulation between what is shown and what is kept hidden is itself reassigned toward new spaces. Retaining only the attractive and seductive force of these online faces, Prince displaced the operations of the capture and channelling of libido toward intermediary spaces, blurring the distinction between true and false, real and fiction, private and public. Under the selfie of the user *carlacrater*, for example, he typed in: 'I'll be home as soon as I can'; beneath the lavish selfie of another, heavily tattooed young woman: 'I put an ad in a swingers magazine & my parents answered it.' And yet at the Gagosian show the artist's Instagram account showed girls mimicking their own poses in front of their enlarged portraits – a performance of performance, a fetish of a fetish. Images within images. Prince plays on surface effects and the imperative of visibility so as to détourn its lurid logic and rediscover an intimacy that has been disseminated and reduced to a stereotype.

For if the visual is essentially pornographic, as Jean Baudrillard once argued, and if the selfie is the placing in tension of a publicized intimacy, it nevertheless passes through the filter of an iconographic dogmatism that, in the end, is essentially normative rather than performative. The great moralizing enterprises that are Apple, Facebook, and Instagram present a scenography of fakes that mediatizes, filters, and veils the obscenity of the world. Smoothing out and stereotyping our identity, they organize planes of subjectivation that relate to another form of psychopower: a power that drives us to self-censorship and forms of self-discipline, as can be observed by surveying the hashtags of the network – for example those advocating wellbeing, healthy eating, or intensive sport. Performing the images, it is the intimate content of these stagings that is acted out, replayed, reappropriated. What counts is not only the *quantity* – of likes or comments – but the *quality* of the spectacularization, of their representation in the almost political sense of the term.

In opening up the conversation, particularly through the intermediary of various emojis, Prince reduced distance, introducing a ludic dimension and a certain proximity. The artist's selfie appropriations became *real-fiction*, fictions (of the) real, of an everyday life, of an identity. So that 'selfie-porn' – its exhibition, its stagings – along with the logic of buzz, of the like and the comment that accompanies it, seemed to be diverted from its primary objective. The selfie was narrated, anchored in an apparatus in which the story and the spectacle were not merely publicity or attention capture. No longer a marketing strategy or 'personal branding', these selfies entered into a space of experimentation with the I, where the close link between the desire for attention and the desire for self-realization could be brought to light.

Often censored by the platform (his account has been closed and then reopened a number of times, a censorship he celebrates), accused of being sexist and provoking anger in relation to copyright and private property, Prince tended to subvert such judgements precisely because his practice of appropriative art produced value. The controversy of June 2015 began with Prince's reposting on his account of an image of a cosmetics maker, Doe Deere. Deere said that she would not sue the artist, unlike the artist Audrey Wollen, the theft of whose image by Prince made her neofeminist theories more visible. The Suicide Girls decided to resell their image, at the time listed at $90,000 by Prince, for $90. Like the 'Streisand effect', the phenomenon of involuntary buzz, the artist's appropriations put in place the conditions of visibility for a joint attention, even if it functioned through a boomerang effect: 'Any one who copies you is turning their audience over to you, and thereby doing you a favor. Even anyone who tries to malign you or distort what you are saying calls attention to you in the process.'[11] This is something Prince understood perfectly well when he published grabs of various insults directed toward him in comments below his screen captures. 'You're a fucking thief', 'Stop stealing people's Instagram photos and passing it off as art', 'That's a nasty joke! How pathetic': so many sweet invectives to complement the work of the prince of thieves.

A New Distribution of the Sensible

Wrenched from the private or semi-private sphere of the intimacy of an Instagram account, these selfies had become the property of an artist and would become the property of collectors when sold in the gallery. These

faces had been monopolized and introduced into an eco-
nomic chain linked to the speculative bubble of the art
market, without those pictured earning a penny from the
deal. But it must be recognized that online self-portraits
have also become the black gold of the great industries
of the 'profile web'. Today, selfies distributed on the
Internet are raw material for the operations of new dis-
tributions of the sensible. *New Portraits* consequently
addresses the transformations of a contemporary 'faci-
ality' which has indeed entered into, and may even be
the anchor of, an economy of fluxes that designates it as
'sign', symbolic double, or consumer product. Extracted
from their metaphysical or 'epiphanic' aura, like all
commodities these faces are now prey to fetishization
and speculation. This is why, today, creative activity
cannot be a simple matter of critique or the manipula-
tion of symbols. It must illuminate and reconfigure our
attentional apparatuses from the perspective of *care*,
meaning a long-term formation of attention.

Whereas selfies and stagings of the self proliferate
on the web, seemingly stripped of their intimate and
individuating dimension, following the postmodern art-
ists Claude Cahun, Cindy Sherman, and Nan Goldin,
the relational investment brought into play by Richard
Prince takes account of the reconfiguring of the 'distri-
bution of the sensible' discussed by Jacques Rancière.[12]
This distribution is characterized as an *immersion* in an
aesthetic experience which, according to Yves Citton,
leads us 'to valorize hitherto unsuspected sensations and
sentiments, and/or to modify the values associated with
them'.[13] It is in this sense that Rancière has written that
'the real must be fictionalized in order to be thought':[14]
art, like politics, does indeed construct 'fictions' – that
is to say, *material* reconfigurations of signs and images,
relations between what is seen and what is said, what

one does and what could be done. Surfing on a contemporary economy that no longer aims simply to *produce*, but rather to develop that rare resource that is reception, Prince's art appropriation is much rather a case of surveillance, selection, and editing. He filtered and chose what he liked and, in doing so, created a joint attention which, paradoxically, took care of the community. Prince's love for counterculture led him to take on the work of a *curator*, in the sense that he reconfigured the map of the sensible by blurring the lines between production and submission to the imperative of this open displaying of faces. Because the artist pays attention to this contemporary ecology of the face, while remaining impassioned by both object *and* subject, because he valorizes them and stages them, he also takes care of this imagery, always liable to be captured, channelled, and controlled for other ends. Between surveillance and dissemination, the individual must continually reinvent their reflexivity by exploiting, as Louise Merzeau suggests, 'both the dysfunctions and the efficiencies of their technological prostheses'.[15]

These images certainly bristle with a conventional superficiality that borrows its codes from a pornographic universe responding to the obsessions of a mass culture in constant search of stimulation, but they also crystallize a common imaginary in search of meaning and recognition. A grandchild of Warhol and Duchamp, Prince opens the way to new readymades, no longer institutionalized by museums but instead consecrated by networks and amateur practices. Taking account of the common participation in the construction of our symbolic universe, Prince indicates the change of climate in our own attention and availability in the face of the flux of images and desires, the solitude of these connected persons, and the community of these singularities.

Instead of an attention *economy*, Prince mobilizes the conditions of an attention *ecology*, taking account of the technical, symbolic, and economic milieus of attention, even though one might fear the rise of the commoditization of *care* even more than that of the intimate. Prince may not manage to short-circuit this environment of fascination and enchantment, but he nevertheless draws out its lines to the point of a reversal where everyday fictions become far more thrilling and real than reality, precisely because they are in contact with the real of drives, behind the law that veils them.

The Algorithmic Matrix: Ranking and Mapping of Faces

Where the portrait genre fixed and identified the traits of a person, today's faces have taken on a fluid and ephemeral temporality, capable of moving across territories and adapted to the real-time nature of our societies. Individuals increasingly change their identity depending upon which network of relations they are navigating: professional, family, artistic, and so on. And yet this nomadism in no way means that the face escapes the politics of facialization. Visibility is a function of new criteria, linked, among other things, to algorithms – that is, to referencing tools such as Google's PageRank, which indexes, classifies, and hierarchizes content, or EdgeRank, developed by Facebook, whose logic focuses on published images that have many 'likes'. Users may be in a position to construct the reality in which they are immersed, but it is these algorithms that will decide on their importance. In the particular case of Facebook, EdgeRank has become an algorithm of *machinic personalization*. It determines at the speed of light that which will 'appear' most important for the user, depending

on buzz, detected affinities, or number of views. As Dominique Cardon explains:

> Whereas PageRank measures the links between documents, Facebook's EdgeRank classifies documents depending on subjective judgements exchanged by persons linked by a relation of affinity. *Rather than erasing the person behind their text, the conversational enunciation of social networks – flexible, loose, and immediate – has allowed the subjectivity of persons to become visible, making their judgment into an identity signal that individuals project in their social lives.* Whereas in the web of documents, the intrinsic, illocutionary force of the link resides in the authority of the page of the text that cites, in the web of persons, it is the digital authority of the enunciator, their e-reputation, that supports their enunciation. The affinity metrics of the social web distribute toward the documents that they classify an authority rooted in the persons whom PageRank wants to erase.[16]

They may be automatic, but Facebook's algorithms are by no means neutral. They encode choices and they establish the architecture of what we see and what we are able to *access*. Similarly, they offer the illusion of an evaluative judgement ordered by a subjectivity, understood as 'digital authority'. EdgeRank is an important component of our own visibility, and harbours political and aesthetic implications. These are tools that drive users to one-upmanship and further exteriorization of their various facets, which 'have a greater tendency to become objectivated, to sediment into traces of the self in social memory: sounds, stories, texts, images, objects, symbols'.[17] Translated into a profile – a set of data calculable by machines – traditional identity, along with the numerous masks or faces that fabricate individuals on the web, raises new questions. Between *praxis* and

poïesis, the digital production of our online presence becomes the result of predictive configurations that anticipate and model the course of our lives in advance.

Between 2012 and 2013, using DNA traces collected in the street on cigarette butts, chewing gum, hair, and nails, the American artist Heather Dewey-Hagbord created reconstructions of the faces of unknown people with a 3D printer. Through laboratory analysis of the traces collected, the artist-researcher was able to discover the origin, sex, eye colour, and approximate weight of the owners. These genetic markers were then converted into digital data which was scanned, layer by layer, by a printer so as to produce the generic mask of a person aged around 25 years old. Under the title *Stranger Vision*, these masks were then hung on the wall above a case whose compartments contained the sample collected, a photograph of where it was found, and the detailed DNA data of the individual.

Although these reconstructed faces remain conjectural since there is no original to compare them to, in 2017 the artist again presented her research as part of the exhibition *A Becoming Resemblance* in collaboration with Chelsea Manning. In 2010, the former military analyst had been sentenced to thirty-five years in prison[18] on a charge of treason for having transmitted classified military documents to WikiLeaks in 2010, in particular relating to errors committed in the Afghanistan and Iraq wars. Once again, the exhibition presented reconstructed masks, thirty of which represented variations on the face of Manning, who had undergone transition and hormonal treatment. From prison she had sent samples of DNA which the artist had used to algorithmically generate *probable* portraits.

The intention of the artist here was to emphasize the extent to which technological tools can push the

boundaries of restrictive thinking rather than simply reinforcing them. Manning suggested that the use of DNA in art offered a 'very postmodern – almost "post-post-modern"'[19] vision of identity and expression, combining chemistry, biology, information, and our ideas about beauty. It opened up the spectrum of *potentialities* (becomings) and *probabilities* (calculations).

The speculation at work in Dewey-Hagbord's practice informs the traces of a past and physically models memorial imaginaries and traces. This is why she was contacted by a forensic expert to help reopen a cold case concerning the death of a young woman some years earlier. Upon the invitation of the FBI, before this, the artist Nancy Burson, a pioneer in the modelling of digital images and the procedures of morphing, had also collaborated in a number of enquiries in which they sought to determine the adult traits of missing children. These predictive logics narrow down the possibilities toward probable forms. The virtual and its field of possibility are smoothed out in favour of a digitization and a program: a *grammatization* that comes from the future.

This reconstruction of probable faces allows us to enter into the field of resemblance; but it also establishes the conditions for a governmentality that operates from the future. Data mining, traceability, and profiling have become tools of anticipation, and probability now trumps potential. This is why, as Antoinette Rouvroy argues, power 'seems to have changed its "targets": no longer living bodies, subjective, actual individuals, but a statistical, impersonal, virtual body, a generic and changing mould'.[20] It is no longer a matter of a bio-power that exerts itself on bodies, but an 'algorithmic governmentality' capable of pre-viewing the movements and potentials of living beings. By anticipating behaviours and profiles, just like the 'precogs' imagined

by Philip K. Dick, this profiling now risks enclosing individuals in speculative bubbles, in parallel with the passage from virtualization to digitization. Whereas the virtual provides for the idea of potential, heterogenesis, and creativity, digitization seems to offer nothing but automation, data, and quantification, leaving little room for the unexpected.

Doubtless it is this speculative scenario that is behind Estonian artist and developer Timo Toots's refusal to accede to his country's request to place his installation *Mémopol-2* at the service of the government. In this project, Toots had succeeded in constructing a 'digital portrait' on the basis of data gleaned from the web. Presented at the Gaîté-Lyrique arts centre during the Mal au Pixel festival in 2012, his multimedia installation collected and then displayed to everybody the personal information left online by an individual, on the basis of a simple scan of their identity card or passport. Once the connection was made, all the administrative and governmental resources online were collected and displayed automatically: data disseminated on social networks, on forums or blogs, CVs, tweets posted, as well as data relating to their school career, their address, salary, political allegiances, criminal record, health, tastes, holidays, and even friends and friends of friends of the person 'scanned'. This work demonstrated the extent to which 'one cannot not leave traces',[21] in the words of Louise Merzeau. As its name indicates, *Mémopol-2* furnished an exemplary illustration of the struggle currently underway for the monopoly on memory. The work is a *mise en abyme* of the strategic issues concerning the management of our metadata, as well as the risks of misappropriation and modelling of the scattered traces we leave behind us.

Each digital portrait contained and could potentially

generate the subjective matrix of individuals or the envelope of a multitude of data. It was the index by which the economy penetrated private life and, more profoundly, our memory. *Mémopol-2* presented a virtual cartography of psycho-collective territories, bringing to light the particularly contemporary self-evidence which consists in 'com-prehending' the individual in the face of a collective. For singularity is indeed very little unless it is related to a *collective* and to the *milieu* that surrounds it. So it is no longer a question of proceeding like Alphonse Bertillon, inventor of criminal anthropometry, sampling each part of the face so as to develop a *synoptic table of physiognomic traits to serve in the study of the 'speaking portrait'*: with Toots's work it is a question of a *mapping* of the face that *connected* and recorded the relations of one person to others, to their environment and to themselves, on the basis of a social graph. What was at stake was no longer the subsumption of singularities under particularities, but the aggregation of particularities so as to produce a singularity to which, like Amazon, one could attribute tastes as a function of tendencies chosen or pre-selected by algorithms.

Nowadays, *relations* are sampled through the prism of a subjective matrix, converted into data. The profiling industries record tastes, moods, facial traits, connected to other faces or connected objects, so as then to place them in *relation* with one another, or with other consumer logics. Translated into a dynamic map, the face is entering a new stage of grammatization which this time will transform its identity algorithmically rather than metrically. As Merzeau emphasizes, '[T]he avatars that the individual invents for himself are but the socialized face of a software-based diffraction of the subject: they employ unifying fictions to dress up an informational decomposition of identity.'[22] But this grammatization,

which makes facial traits and fingerprints into a set of biometric traces and data with infinitesimal values, still cannot be a 'personless' identity. Humans have not removed the mask that has for centuries permitted them to recognize one another, only, as Giorgio Agamben says, 'to consign their identity to something that belongs to them in an intimate and exclusive way but with which they can in no way identify'.[23] Just as fingerprints are still of a human order, our digital profile depends in part upon images and traces disseminated on the web which suggest our presence as well as our absence. Beyond and beneath these 'infra-personal' digital data, we always find singularities that exhibit choices and tastes, and in which are condensed a politics of permanent closure and retrieval of contents. 'All flows and objects', remarks Guattari, 'must be related to a subjective totalization.'[24] And, beneath the diversity of abstract coordinates, it is the face that localizes this subjective totalization. It remains the expression of an 'ideal pole'[25] that *clothes* the flows. The reduction of the face to a set of traces, biometric or informational, is therefore only the logical continuation of a programme of discretization in which it is converted into a flow of data, at once unpredictable and calculable, discrete and relational. But in doing so, the human gradually leaves behind its originary ontological identification, its definition gradually displaced as it moves further into the prosthetic realm.

6
In the Flow

Foucault wagered that the face of man 'would be erased, like a face drawn in sand at the edge of the sea'. Like many of his contemporaries, he was haunted by a longing to disappear by neutralizing his position as a writing subject. The enunciator was to be effaced in favour of the writing or the trace, which would develop autonomously, and be received with neither origin nor intention. From the celebrated Anonymous to the authors of the Invisible Committee, from chameleon-like artists such as Liu Bolin, Désirée Dolron, and Kimiko Yoshida to the fluoro cagoules of Pussy Riot and the helmets of Daft Punk, the contemporary ethos seems to have been contaminated by a basic tendency toward practices of anonymity. It does not seem plausible to explain this with the idea that faces have become publicity in the service of personal branding or to the benefit of large firms such as Facebook, or that traceability and profiling are driving individuals to withdraw from a predatory regime of visibility. The deliberate disappearance of the face, its flight from all visual capture, turns anonymity into an offensive force rather than a state of defence or resistance. It is based on an ethics of camouflage that

adapts itself to its new environment all the better to reconfigure it.

Of Dissemination?

With the machine-face of *A Thousand Plateaus*, described by Bertrand Vergely as 'paranoiac',[1] Deleuze and Guattari already presented a theoretical fiction that made it possible to think the disappearance of the face and its martial strategies. A little less than half a century later, the becoming a-signifiant and a-subjective promoted by the duo is enjoying a certain ascendancy. If man has a destiny, they affirmed, 'it is rather to escape the face, to dismantle the face and facializations, to become imperceptible, to become clandestine [. . .]. Yes, the face has a great future, but only if it is destroyed, dismantled.'[2] But by dint of violating faces, erasing them, placing them in series or spectra, nothing now remains but 'heads without faces or more or less ironic metaphors of the portrait'.[3] Exploited to the point of being torn apart, has the face itself been defaced?

Has the Nietzsche-inspired vision of an essentially nomadic and differential individual come up against its limits? Transformed into an image of images, oscillating from the imperceptible to an anti-aesthetic, non-anthropomorphic, non-humanist programme, beneath and beyond all traditional ontologies, the face becomes a 'non-face'. But why did this philosophy of the face present itself as an aesthetic paradigm? Why, even though Deleuze and Guattari warned of the dangers of such an operation, do artists still continue to attack faces? Probably because this philosophy was contemporary with a vast movement of fluidification: with structuralism on the wane, deconstruction plunged representation into crisis, the metaphysics of the subject

exploded, and financial flows took over. But it was also contemporary with the rise of theories of photography and cinema, index and referent, in which the photographing of a face was still thought of as the trace of an event – 'this happened' – and theorists had begun to debate or even to 'denounce the abusive identitarian dimension of ontological theory'.[4]

To the eyes of Fredric Jameson, Edvard Munch's *The Scream* constituted the canonical expression of the great modern themes, namely 'alienation, anomie, solitude, social fragmentation, and isolation'.[5] The author of *Postmodernism* demonstrated the extent to which the aesthetics of expression had almost disappeared in the universe of 'late capitalism'. For Jameson, this expression presupposed a 'separation within the subject'[6] that projected this exteriorized emotion toward the exterior as a gesture or a cry. Postmodern and poststructuralist theories seem to have repudiated this hermeneutics of the subject in favour of a paradigm of surfaces, fragments, and fluxes. For them it is no longer a matter of a hermeneutics of the depths of the subject, but of its surfaces of appearance, in which the logic of alternatives is also dissolved. The anguish and alienation typical of 'high modernism' no longer had any pertinence in the postmodern world of late capitalism – or, at least, they had mutated into something else.

With the appearance of image editing software and the arrival of the web, the 1990s would be marked by a posthuman iconography that liberated creativity from its realist constraints, and humans from their biological condition. Accompanying or outstripping the biomedical imaginary, artists such as Nancy Burson, Keith Cottingham, LawickMüller, Aziz+Crucher, Matthew Barney, and Orlan experimented with digital plasticity – with its properties of circulation, diffusion,

and hybridization – and encouraged the slippage of the problematic of the body – become obsolete and nomadic – toward that of the face, so as to insist upon an epoch characterized by interfaces – the dominion of the screen – and shaped by new modalities of power. The plasticity of the media pursued the quest for a 'personless' face in-becoming, for which identity was the effect of a process of multiple identifications. Faces were anonymous, desexualized, cut off from their existential and biological referents.

From Warhol's *Marilyns* to Sherman's *Selfies* on her Instagram account, this was ultimately the *death* of the subject itself and thus 'the end of the autonomous bourgeois monad or ego or individual',[7] which had disintegrated little by little, for at least two reasons. The first, as argued by Jameson, is that the centred subject, product of the period of classical capitalism and the nuclear family, was replaced by a fragmented subject. The second is very simply that such a subject never really existed, that it was at best an invention designed for the preservation of the species.

To the slogan 'Je suis Charlie' François De Smet responded, in his book *Lost Ego*, that the central question to ask was not 'Who is Charlie?' but 'Who is I?'[8] Free will is a necessary fiction for the functioning of society. For De Smet, consciousness is only the result of a synthesis created by our brains, the residue of a *narrative* that we tell whoever will listen. This simulated construction perpetuates the Darwinian logic of the conservation of the species, the most successful subjects being those that manage 'to construct a coherent representation of themselves within their environment'.[9] The individual keeps within his or her comfort zone by adhering to the group and to established values, in obedience rather than resistance. Does thinking anonymity

today come down to thinking the 'I' and its adaptation to a fluid medium? Does this allow us to conceive of the production of a commons?

In *Foucault anonymat*, Érik Bordeleau tries to understand the word 'anonymity' in a broad and literal sense that goes beyond the everyday usage. This implies 'bringing to light the complex of experiences and challenges involved in trying to "exist in that which has no name" and to "know how to recognize both the temptation toward publicity and the impotence of private existence"'.[10] Far from being understood as a loss, anonymity justifies the deprivation of oneself in order to think and perceive otherwise, a practice of the *non-place*. And indeed Bordeleau connects his thinking to that of Marc Augé, for whom '[t]he community of human destinies is experienced in the anonymity of non-place, and in solitude'.[11] In other words, it is by favouring desubjectivation and the exit from private interiority that one makes oneself available for new possibilities of existence. Where Foucault ceaselessly sought to disappear and 'to no longer have a face' so as to insert himself where 'something happens between us', the selfie, a figure par excellence of anonymity, opens toward a power of dissemination whose future paradigm-to-come it is urgent to perceive.

The shifting of man's interest toward his milieu, the move from a vision privileging the moral and ethical status of man to one more engaged with his place in the wider environment, indexes a change in the relations between man and world, between man and the power of time, between man and the formation of new systems of values brought about by impermanence and flux, long considered in the West as negative. To cede to the liquidation of identity and to protest at the shattering of the subject would be to neglect the extent to which it is flux that forges and constitutes man.

Innovative and performative in nature, contemporary thought is moving toward a comprehension of beings that is not strictly ontological but topological. Going beyond a strictly topographical vision of spaces, topology is a 'discourse on place' predominantly in terms of the notions of neighbourhood, continuity, and limit. The need to go beyond the representation or study of phenomena and to engage with interactions and correlations makes it necessary to return to certain postmodern notions. Although Anne Cauquelin is right to emphasize the impasses and gaps in such a continuity, and although the digital resonances of 'cult' notions such as the rhizome, nomadism, deterritorialization, and deconstruction may seem impoverished in comparison to their philosophical and emancipatory intentions,[12] they have nonetheless revealed connections and affinities with these concepts. The reticular conception of our contemporaneity, alongside the proliferation of geolocalizing devices, indexes our concern with our place in the world, we who can be mobile without ever leaving home. This relation to the world configures new modes of participation and worldmaking, if or even 'becoming-world', even if it constrains us to a diffuse circulation. To be with and in time is to be in the world; it is to live with other realities, to connect and interact with them, at the heart of an everyday life that is increasingly virtualized, reflecting a society that is moving beyond its field of perception. The human is no longer in the middle of the world; it has become a milieu. It pollinates like bees and proliferates everywhere like couch grass.

Aesthetics of the Everyday and Becoming-World

Never has an era been so interested in its own contemporaneity as ours. The Middle Ages looked to

eternity, the Renaissance toward rediscovery of the past, Modernity to the future and the idea of progress. Our era is characterized by a passion for contemporaneity and the contemporary, which finds its justification in a regime of historicity centred on the present. The growing number of museums of contemporary art is another sign of an era in the throes of self-exhibition, as well as the constitution of a knowledge and real-time archive of itself.

In *The Practice of Everyday Life*, Michel de Certeau, like Martin Heidegger, Henri Lefebvre, and Maurice Blanchot before him, invites us to pay attention to the *performative* dimension of the everyday.[13] The everyday only exists by way of practices which, by revealing it, make it exist, invent it. Eating, talking, cooking, taking the bus, the metro, or an elevator or taking a selfie are so many micro-activities that make up our everyday life and which, when diffused across networks, fabricate an imagery of the ordinary. These images 'without qualities' convey an imaginary horizon constituted of banal photographs which, since they reflect the moods of a collective in the 'here and now', nevertheless determine an aesthetic of the everyday in real time; at least, they afford a glimpse into the tendencies emerging in the everyday. By continually archiving 'whatever', these journalling practices inaugurate new modes of action and of making use of the everyday. To the point where today, as Julien Verhaege suggests, what takes priority is an 'everyday of representation' rather than a 'representation of the everyday'[14] – the idea being that the everyday, in order to be portrayed, must perpetuate the dynamics that run through it, whereas, inversely, a representation of the everyday produces an 'inoperative tracing' so as to understand our contemporary life. In short, rather than thinking the everyday, lived experi-

ence, the act or the performance, we must become as one with it.

This vision of a performative everyday resonates with Boris Groys's reflections on the distinction he makes between technical and digital reproduction.[15] Where Benjamin condemns the modern epoch for destroying the 'aura' through mechanical reproduction and losing the *hic et nunc* of the artwork, 'the unique existence at the place where it happens to be',[16] contemporary practices 'perform' images like a musical score that will never be reproduced identically. If the recording of traces by profiling apparatuses consists as much in subtracting these traces from the gaze as in *grammatizing* them, and thus dispossessing them of their memories, these days individuals employ techniques of 'bricolage', offering their images to a spectator hidden behind the screen of their computer or telephone. So that selfies are performances that proceed via *adoption* and *adaptation*, in which images of others gain the status of self-images as they spread: the face slides into the interstices of time and of its environment.

Wrongly perceived as retrograde narcissism, in this sense selfies in fact make for the possibility of a new mode of contact with others and with the milieu. They are 'bubbles placed in a network', as Sloterdijk might say. For this singular specular gesture introduces a 'new imaginary and visual language [. . .], one which upholds and reinforces the emotion inhering in an imagined "being together"'.[17] So that, in a second stage, the diffusion of anonymous self-portraits across networks reinforces a feeling of participation in the world, by symbolizing individual lived experience in the style of the collective. This construction in the present of a real heightened by moments that strictly speaking are unimportant – selfies in elevators, rear-view mirrors,

or public toilets -- mobilizes an imaginary of the everyday that depicts a world that is familiar and shared by all. The relational dimension of these faces rests not so much upon what is objectively seen as upon what connotations they hold for each person's memory. In this sense, such selfies refer to a collective face built up from a reservoir of shared perceptions of the everyday. So it is not the return of the other in the perception of faces that lies at the origin of the relational apparatus – since the gaze loops back on itself and demands a form of compliance driven by the possibility of collecting comments and likes – but the inauguration of gestures and attitudes that are universally and unanimously shared.

Whereas the photography of industrial capitalism distanced individuals by assigning each one to a fixed case, sequestering them by class, colour, language, age, and so on, digital interfaces, like advertising, cross frontiers and media, bringing together individuals without the slightest distinction; whence the necessity for individuals to produce themselves through self-classifications that link them to a community. The uses of photography today allow those who submit to them, by overinvesting in emotions as a link to the other, to enter into contact with and to participate in an all, an all that can only be experienced through them. As Emanuele Coccia reminds us, 'it is thanks to mechanical reproduction that man lives in the world and is not locked in the world.'[18] By amplifying the organs of man as well as his spatio-temporal limits, technics overflow biological nature and open onto the possible, onto limitless plasticity. '[H]aving a relation with things – producing, acquiring, dreaming of, thinking about, or exchanging commodities,' says Coccia, 'means changing the shape of the natural world we live in and belong to. This is why our relationship to commodities is always the crystallization

of a kind of mobile cosmology.'[19] Mass adornment, the grammatization of our existence, the face as commodity, through their mundanity and their capacity to make a world, can then be understood as an ordering into a *kosmos*. For, as Coccia recalls, *kosmos* in Greek means 'beauty, ornament, elegance'; to which he adds that '[a]ccording to Alexander von Humboldt's ingenious formulation, *kosmos* – the world – is simply "the ornament of the ordered"'.[20] If publicity produces the *inventory* of things as they appear by naming them one by one, describing them, ordering them and cataloguing them, albeit clumsily, it clarifies the augmented [*appareillé*] and positively reifying nature of our subjection to forms of self-design. Basically, ornament is the reflection of the rationality sought not so much by the dominant economic system as by a cosmic force that cannot be reduced to a human force.

Facebook and Instagram, to cite only two social networks, encourage a socialized use of images of oneself, just like the *cartes de visites* of the 1860s. What is fundamentally different about these contemporary practices, however, is their 'presentism' and interactivity. The slow temporality of traditional media has been succeeded by the instantaneous actualization of contemporary technologies. Images produced in a studio or at special events have been succeeded by a flux of 'eventless', 'pointless' images without any desire for filiation. What counts is the sharing, the diffusion, the accumulation, and, in fact, the present of actualization. With this conception of time and of the time of photography, we must concede that digital images have the potential to penetrate into the very heart of a reality developing in real time. In other words, we must insist on the becoming-flux of this image that now inhabits and clothes the world as it produces its ornament, and

in which the amateur is guided not by the desire to produce the 'truth of a memory', in Bourdieu's words, but by the desire to acquire and to enact images according to the logic of a 'social game'[21] in which each can converse and produce his or her vision of the world.

Pervasive Faces

With mobile and connected telephony, therefore, the groundwork has been laid for a 'pervasive' photography – that is to say, for an image that infiltrates itself into the everyday to the point where it ends up actually producing its very fabric. Our everyday life is the product of a real-time archiving whose mesh is becoming continually denser and more miniaturized, while individuals in their everyday movements are themselves interconnected by multiple personal terminals. These connected devices armed with tiny cameras and microphones record the everyday, duplicate it, and diffuse it in real time on social networks. Such practices consequently introduce forms of everyday immersion-interaction that define new ways of living in the world, participating in it, and being one with it. The devices therefore present us with the spectacle of an everyday life fictionalizing itself at the same time as it is actualized.

Although we generally use the word 'pervasive' in the context of environments,[22] primarily to signify the spontaneous communication of objects connected with other objects, we could also envisage a communication of images with other images, of faces with other faces. Through generalized indexing, the face continues its movement toward becoming a living document, a dynamic and interactive document fuelled by emojis and keywords, localization, and timestamps. Today the face moves within an ecology of circulation and hyperlinks.

But as it inscribes itself within a network of signs and metadata that organize its visibility, it confers upon the eye a haptic function which induces a kinaesthetic perception of the body within the environment. The immediacy of exchanges and the fusion of body and milieu condition a relation of immersion/emersion in the world. This way of being present with one another defines yet other ways of 'becoming-world' – that is to say, of becoming one with the world.

When Liu Bolin or Kimiko Yoshida disappears into the surface of the image, Bolin with the aim of denouncing his cultural and political heritage, Yoshida's self-portraits composing a 'series of identities, a multiplicity of reflections that succeed one another like the sequence of thoughts',[23] what is at play is a paradigm of impermanence but also one of assimilation, if not absorption, by the milieu. Liu integrates his form into the background with ultra-perfected body painting which transforms him into a statue for hours on end. In his first series of camouflage pieces, the artist posed in front of propaganda slogans in favour of the one-child policy or obligatory voting; he was also seen standing to attention in the famous Tiananmen Square, historical site of significant events, watched over by the portrait of Mao. Like a subliminal message, the Chinese artist touches consciences as one colonizes imaginaries.

Although it is often said of Liu and other masked protagonists that they are trying to subvert the panoptic apparatus of societies of control, this is to underestimate the force of this politics of the imperceptible. From the quest for visibility to the imperative to see and be seen, subjects are not just the victims of rigid discipline, but also permanent actors in their own 'veillance', whether it comes from above or below. 'No doubt power, if we consider it in the abstract, neither sees nor speaks. [. . .]

But precisely because it does not itself speak and see, it makes us see and speak,'[24] as Deleuze wrote in reference to the diagram in Foucault. Precisely by rendering these invisible logics visible, Liu goes beyond a mere reversal of the formula; he makes himself into a diagram. As the artist himself says,

> [E]veryone can choose their own way and their own mode of connection to the external world. I have decided to blend into the environment. Some have said that I disappear into the landscape; what I would say is that it is the environment that takes hold of me and that I cannot choose whether to be active or passive.[25]

This prompts the question of assimilation or impregnation by the milieu. And although becoming one with the décor or blending into the landscape obviously suggests a desire to conceal oneself, and even to escape a certain tyranny of visibility or permanent surveillance, in his photo-performances Liu does not withdraw from the world – on the contrary: he becomes-world. Reassigning the modalities of the visible according to a principle of alternation between seeing and not seeing, his approach manifests a desire to insert oneself into the fault lines of the real. If the human is no longer in the milieu of the world, but has become milieu, he tends to become one with an environment where, as Deleuze and Guattari write, '[o]ne has painted the world on oneself, not oneself on the world'.[26] Affirming his belonging to the milieu, he joins in with its transformations, participates in its metamorphoses, and, like a stick insect or chameleon, uses camouflage as a means of adaptation.

According to the American painter Abbott Thayer, who carried out the first experiments with camouflage, natural selection favoured a world full of animals with the gift of temporary invisibility. All animals – except

for human beings – are capable of camouflaging themselves and blending into their environment. They tend to disappear at '"crucial moments" of utmost physical vulnerability'.[27]

Couch-grass Politics, or the Ethics of the Chameleon

Artists practising the art of camouflage with military strategies of infiltration; selfies connected to the discretization of 'personless' profiles – there is a strange consensus in operation here. On one side, we have a deliberate disappearance of faces; on the other, the manifestation of an escalation unequalled in the history of humanity, a politics of anonymization as the counterpart of a politics of exhibition – yet both suggest the same paradigm, the paradigm of the 'pervasive'. The Latin *pervasus* means 'to go everywhere, to insinuate, to propagate, to penetrate into, to extend, impregnate, spread, to make spread, to invade'. Trading on a couch-grass politics, proliferating like weeds, both of these strategies are a matter of anonymity understood in its extended sense. An anonymity, however, that remains attached to a logic of ostentation, for otherwise the human would be adapting with neither purpose nor sense. As Hanna Rose Shell recalls, coined in 1914 – at a moment of crucial vulnerability – the term 'camouflage' derives from a double etymology:

> On the one hand, 'camouflage' harkens back to the nineteenth-century French word *camouflet*, which refers either to a primitive land mine that creates potent underground explosions without surface rupture or to a tiny smoke bomb that explodes when placed into the nose of an unwitting victim. 'Camouflage' is also related to the medieval Italian *camuffare*, meaning to 'make up'.[28]

Like a woman making herself up, applying blusher, dissimulation by way of camouflage aims to *anticipate* the gaze of a potential spectator or enemy. An anticipation that is made necessary by the predictive logics of grammatization. But one might go further and say that camouflage combines the animality of the human and its originary artefactual nature. To camouflage is to bring together the two extreme poles that have always defined the human. Whereas in the classical age, as Tristan Garcia summarizes, 'humanity recognised itself by self-differentiating from animals and machines, identifying itself between them', in the modern age 'humanity recognised itself by differentiating animals and machines, identified as the two limits of humanity's being'.[29] The contemporary epoch, the digital age, brings back the survival and predation instincts of humans who feel that at every moment they are being tracked by their own past, their own footsteps and traces. In becoming their own observers, individuals experience the original separation of their face as a scission between a real identity, in flesh and blood, and a virtual, discretized identity reduced to data, to traceability. It is as if we were hunting ourselves, following our own tracks, as if it were a matter of fooling, of anticipating, of surprising ourselves so as to conserve our unpredictability.

The technique of camouflage appeared at the same historical moment as the invention of aerial photography – a vision at once cartographic and dynamic, and which involved the surveying of those who were *exposed*. What camouflage shares with the modern diagram of the 'mapping' of faces is an attitude of defence against the technical translation of faces. When the United States entered the war in 1943, Jean Labatut, architect and professor at Princeton, rather than insisting on existing techniques of camouflage that aimed to make a body

disappear (painting, meshes, special effects), taught on the 'consciousness and discipline of camouflage', insisting that the method of camouflage was not a matter of mimetism, as Shell writes,

> but rather a technological system in which the self is implicated and through which the modification of the self is structured. That technological system comes into being through practices of collage and innovation. As part of this process, the self is inscribed and reinscribed, while being rendered absent, within the contours of a larger media ecology.[30]

The discipline of camouflage promised to make the self into an immersive potential spanning between animal survival strategies and a machinic development in the direction of its identification with the media milieu. Rather than render itself indiscernible and hide in its environment, it had to adopt the form of that environment. Since we cannot escape the order of the visible via intrinsically predatorial invisible techniques, since the Muslim woman's veil transforms her into an all the more visible image,[31] since the permanent watching of people over one another is as effective as night-sights on a camouflaged soldier's uniform, and since it 'is impossible not to leave traces', the only way out is to encourage a general awareness of camouflage, which implies a direct link with the ecology of our natural, social, and media environment and the integral part that camouflage plays in it. Rather than being understood as a flight, in David Le Breton's sense,[32] or a pathological evacuation of identity, or a 'self-destructive psychasthenia', in Roger Caillois's terms,[33] this aspiration to disappearance is a way of taking advantage of the immediate environment within which one moves. Rather than creeping, using the foliage of

the jungle, the reeds of the riverbank, the wheat of the fields, the coal in the mine, rather than making yourself one with the earth or with nature, the ethics of the contemporary chameleon involves dissemination, reification in the trace, hypervisibility as a strategy of invisibility, in order to blend into the mass of fluxes and to avoid being captured by remaining static.

The discretization of individuals into imperceptible traces referring the individual toward a 'personless' recognition now becomes a new way of creating masks, which grow gradually thinner. But this personless skin or organ still has two sides to it. The artificial organ plays the role of a surface or 'façade'[34] of contact and delimitation, ensuring the functions of containment and communication with the other.[35] But far more than this, it retains its function as an interface between subject and object.

The new singularity constructed by digital graphs and data is no longer a body without organs combating a deadly automatism, but an organ without bodies whose 'indistinction between signals and things', Antoinette Rouvroy insists, spells the end of both our 'fictions' and our 'administrative and legal regimes, since there is no longer any need to reconnect with a world from which we have been separated: we are now entirely digitally absorbed into the digital world, immersed in and traversed by fluxes'.[36] This dimension – one of *neutralization* rather than *normalization*, 'ridding the world of its representations in favour of a reality made of digital fluxes',[37] is a process of *reification*, but one whose comprehension is still driven by the claim to an *absolute nakedness* which, according to a well-worn consensus, continually emphasizes the alienation and negative aspects of the technics that reveal us.

The Greeks were paralysed by the idea that the mirror

could reify them at the moment they discovered their reflection in polished metal. The persistence of the technical unconscious is such that, even today, it seems difficult to extract oneself from it, like a Promethean shame that will never leave us. Once more, Emanuele Coccia, in the little Copernican revolutions that he operates in his analyses of the commodity, tells us that

> there's a splendor and a euphoria in coinciding with things and their form, which each of us feels in the act of creation. The painter aspires to reify his gaze on the canvas; the craftsman or designer struggles to capture the human spirit in an object; and every novel is a process of reification.[38]

From the object to the imprint, from the imprint to numerical data, discretization, like camouflage, responds to a way of blending into the décor and ornamentation through a *cultivated* form of subjectivity. The ethics of the chameleon is a technique of the self that does not aim at adaptation for adaptation's sake – otherwise we would consume ourselves without making any progress. In *Global Burnout*, Pascal Chabot clarifies that '[w]e adapt to an environment, but we also attempt to shape it, making modifications that suit our own needs'.[39] The evolution of the milieu thus actualizes the potentialities of the human – so that to affirm the dissolution of the person by algorithmic profiling is still to *forget* that humans are fundamentally constituted by the techniques of their epoch and that each technique carries with it an unconscious that shapes imaginaries of the human. 'In any event,' according to Bruno Latour, 'nothing is sufficiently inhuman to dissolve human beings in it and announce their death.'[40] The optimization of interactions between individuals and their milieu, the fluidification of which took a machinic turn in the industrial era, marks only the first moment of development, a principle

that is more ecological than despotic, on condition that we understand its pharmacology.

The avalanches of industrial flows constrained humans to adapt themselves to non-human, non-biological, and anti-natural rhythms; they brought to the surface the *narcissistic narcosis* that takes place in man's encounter with the technics that extend his organs and senses. We have now arrived at a new stage: we have to accept that technics is not *other* – it is 'us'. Technics is not a tool that enables us to achieve our goals, nor even a slave that has to be tamed so as to avoid any rebellion. It is thanks to technics, paradoxically, that our inscription within the world is made more natural, even when its rhythms and its functioning are quite beyond the scale of human comprehension. We must accept that technical objects have their own mode of existence and that, as Simondon argues, they too boast a 'human reality', but a human reality that is 'foreign to humans'.[41]

The Thing's Share

The comprehension of the face as technical object finally allows the founding of a relation of love between subject-face and object-face, between the human and its artificial organ. Simondon was the first to rehabilitate the human reality of the technical object, and to forbid himself from thinking any opposition between technics and culture, between machine and man. According to him, this opposition was only a 'primitive xenophobia' wherein culture behaved toward the technical object as man behaves toward the foreigner and other species. For Simondon,

Misoneism directed against machines is not so much a hatred of novelty as it is a rejection of a strange or for-

eign reality. However, this strange or foreign being is still human, and a complete culture is one which enables us to discover the foreign or strange as human. Furthermore, the machine is the stranger; it is the stranger inside which something human is locked up, misunderstood, materialized, enslaved, and yet which nevertheless remains human all the same.[42]

Throughout the history of the face recounted in these pages, the boundary between subject-face and object-face has tended to disappear, or at least to become porous. It is no longer a question of anything but the face, exteriorized onto a support, evolving to the rhythm of its technogenesis and alive in a manner that is independent of the fabricating activity of man. The object-face may be no more autonomous than the fictions of the 'I', yet it is linked to its *other*: the subject-face with which are elaborated ontogenesis and its related imaginaries. There is therefore some humanity in technical objects not only, as Latour thinks,[43] because we delegate tasks to them, but also because they fashion various parts of our existence. As Eduardo Kohn says, in so far as the human must learn to live with an ever-growing variety of forms of life – whether companion animals, weeds, or technoscientific mutants – 'developing a precise way to analyze how the human is both distinct from and continuous with that which lies beyond it is both crucial and timely'.[44] In order to do so, we would need to 'see' from the point of view of the object-face and thus to adopt a new form of 'perspectivism' like that elaborated by Eduardo Viveiros de Castro.[45] Viveiros de Castro's conception, which draws on Amerindian thought, suggests that the world is inhabited by different species of subjects and persons, human and non-human, each of which apprehends it according to distinct points of view.

This implies a consideration of the relations and interactions of the multiple beings who people the cosmos, in an 'ecology of selves'.[46] Such a conception demands that we call into question the traditional distinction between nature and culture, whose ontological foundation is the separation of subjective and objective domains. It also considers that the human form and human culture can be attributed to other animal species. In the world of the jaguar, the animal is 'human' for itself. The identity *of that which is* human is *taken on* by whoever says 'I', whoever adopts this form, because it possesses a point of view on the world by virtue of envisaging itself in this world. This conception of the human is 'virtually always associated with the idea that the visible form of every species is an envelope (a "clothing"), concealing an internal human form'.[47] This internal form is the *spirit* (of the animal); it is a *personification* that may be materialized in a human corporeal schema hidden beneath a *mask*.

Artefacts therefore have an ambiguous ontology. This is not to follow Philippe Descola in seeing this as a form of animism, but to extend human nature to technical being and its mediations in the sense that, as Simondon anticipated, 'this word "nature" could be used to designate the remainder of what is original, prior even to the humanity constituted in man'.[48] This human reality alien to humans is not without a certain relation to the second pair of eyes that came to rest upon man from the very moment when he became his own observer. This double gaze consequently *participates* in a double point of view – it is an *agent* and not simply a thing, even though the pride of the human species untiringly seeks to make Being rise again from its ashes.

The forgetting of the origins of the face concerns repetition and the return of the repressed, as theorized

by Freud in relation to the phobia of a young boy: '[A] thing which has not been understood inevitably reappears; like an unlaid ghost, it cannot rest until the mystery has been solved and the spell broken.'[49] But this is a reappearance that is more violent every time, and forces the human and the non-human into a confrontation with a-human forms. It is therefore time to understand the face no longer in terms of an opposition between its poles of identification, subject and object, but in terms of transduction. The face as technical object ultimately leads us to a theory of the milieu and of adaptation concerning relations between, on one hand, a technically apparelled [*appareillée*] humanity and, on the other, the emergence of an emancipated technics. Rather than conceding to the supposition that humanity is alienated by technics, we must envisage the relations between the different milieus – the associated milieu and the human milieu – within which the *political* effects of these technics are deployed on the cognitive, psychic, and affective apparatuses of individuals.

The face appears as a privileged support at the centre of this tripartite relation, at the same time as it constitutes a sensible relay for epoch-making and world-making. It allows us to apprehend the mutations of an epoch, to 'envisage' its futures, by penetrating its representations, its memories, and its imaginaries: everything that constitutes the raw materials a society uses to project itself, to re-flect itself.

Every epoch domesticates, delimits, traces a face in the sand. The poststructuralist moment had its uses for interrogating our cultural traits, critiquing our conformisms and our limits, but now it seems that, like a machine repackaged and short-circuited by neoliberalism, it does not have the sufficient resources to think the alternatives that humankind and our epoch have need of, in

order to piece themselves back together. The ecological approach that is emerging today, prior to thinking itself in its relation to the environment, proceeds by way of a transductive operation, evaluating the ways in which the everyday relations of individuals with *apparatuses* (objects and representations) at once submits those individuals to their logics and becomes something like an extension of themselves. Simondon clarifies, in relation to the mode of being of technical objects, that this 'individualization is possible through the recurrence of causality in a milieu that technical being creates around itself and which conditions it as it is conditioned by it'.[50] By miniaturizing and accelerating the technics of the face's grammatization, the contemporary epoch tends toward a discrete co-appearance and an immediacy the illusion of which would be to think that it defines the humanness of the human. The face is but one instance in a systematic and total process of the exteriorization of all organs which, as Leroi-Gourhan was convinced, implies a liberation from biological servitude. But this ends up posing an important problem: What is left of man at the end of this evolution?

> Freed from tools, gestures, muscles, from programming actions, from memory, freed from imagination by the perfection of the broadcasting media, freed from the animal world, the plant world, from cold, from microbes, from the unknown world of mountains and seas, zoological *Homo sapiens* is probably nearing the end of his career.[51]

The human can be neither grasped nor saved unless we give it back this other half of itself, the thing's share: its object-face. Thus the ethics of the chameleon becomes a way of responding to the end of man. It is a survival strategy that functions via modulation-disappearance, an in-between spanning the gap between

its animality and its technical supplement, and aiming at the adaptation of the human to its milieu and its individuation. Consequently, the associated milieu cannot be understood simply as that which surrounds the human as it is individuated: it is more like a *partner* for the human. In the specular relation between the subject-face and its object-face, then, what comes into view is a perspectivist turn by means of which each existent will see itself as 'human' while perceiving the other as stranger.

Now, given the duality of this principle, the face cannot occupy the human point of view of two species, or modes of existence, at the same time. Viveiros de Castro tells us that 'in every confrontation here and now between two species, it is inevitable that one will finish by imposing its humanity on the other, that is, that it will finish by making the other "forget" its own humanity'.[52] The forgetting of the origins of the face is a relentless living out of this abandonment of the human nature of its other. To consider the face-object as a human would amount to abandoning the position of the subject and becoming a potential object of predation for the other. Inversely, taking up the position of the subject would amount to falling back on ourselves, considering the non-human that makes up our other half only in the form of a non-face, reduced to a secondary reality.

The face proceeds from a polarity, whose image-object is 'a germ capable of coming to life and developing in the subject'.[53] It may not be a question of thinking in terms of autonomy, but the human's continued, banal observation of itself turns out to be a singular adventure that reveals the secret humanity of the non-human existents that make up the face. Our attempted opening up of the *black box* of the face can now be brought to

a close, so that the forgetting of its origins, its historic-
ity, its controversies, and its internal functioning can be
covered over by new theoretical *fictions*, essential to its
psychic development and to the survival of its species.

Notes

Chapter 1 After the Face

1 'Investigating the Style of Self-Portraits (Selfies) in Five Cities across the World', http://selfiecity.net.

2 André Gunthert, 'La consécration du *selfie*', *Études photographiques* 32 (Spring 2015), https://etudes-photographiques.revues.org/3529.

3 Peter Sloterdijk, *Spheres 1: Bubbles Microspherology*, translated by Wieland Hoban (Los Angeles: Semiotext(e), 2011), 86.

4 Gilles Deleuze and Félix Guattari, *Anti-Oedipus: Capitalism and Schizophrenia*, translated by Robert Hurley, Mark Seem, and Helen R. Lane (London and New York: Continuum, 2004), 112.

Chapter 2 The Invention of the Face

1 Walter Benjamin, 'Little History of Photography', in *Selected Writings, Volume 2, 1927–1934*, translated by Rodney Livingstone et al. (Cambridge, MA, and London: Belknap Press of Harvard University Press, 1999), 507–30: 518.

2 [With its proximity to *apparaître* (to appear) and *apparat* (ceremonial), the term *appareil* (apparatus

or device, but also specifically the camera), along with *appareiller* and *appareillage*, plays a special part in this work, going to the heart of its preoccupations. This family of French words can designate both a technical equipping or readying and a cosmetic enhancing of appearance, covering a broad spectrum of *preparations* from the functional to the ceremonial – from fitting with a prosthesis to kitting out a ship to making up a face or dressing, as in the English *apparel*. *Apparatus* has the same roots and has become a standard translation for *appareil*, but the other terms pose more of a difficulty. Although certain terms cover a similar range of meanings (to rig or fit out, accoutre, array, provision), in order to mark the consistency of the term and to reinforce the link with *appearance* and *apparatus*, I have used cognates of *apparel* while retaining the original terms in brackets. As discussed below, the works of Jean-Louis Déotte explore the questions in great detail. – Translator's note]

3 Walter Benjamin, 'The Work of Art in the Age of Its Technological Reproducibility [First Version]', translated by Michael W. Jennings, *Grey Room* 39 (Spring 2010), 11–38: 25.
4 Charles Baudelaire, 'The Modern Public and Photography', in Alan Trachtenberg (ed.), *Classic Essays on Photography* (New Haven, CT: Leete's Island Books, 1980), 83–9: 86–7.
5 Ibid., 89.
6 Bernard Stiegler, *Symbolic Misery, Volume 2: The Catastrophe of the Sensible*, translated by Barnaby Norman (Cambridge: Polity, 2015), 9–10.
7 Michel Foucault, *Discipline and Punish: The Birth of the Prison*, translated by Alan Sheridan (New York: Vintage, 1995), 200.

8 Walter Benjamin, 'The Work of Art in the Age of Mechanical Reproduction', translated by Harry Zohn, in *Illuminations*, ed. Hannah Arendt (New York: Schocken, 1968), 217–51: 251.

9 Michel Foucault, *The Order of Things: An Archaeology of the Human Sciences* (Oxford and New York: Routledge, 1989), 387.

10 Bruno Latour, *We Have Never Been Modern*, translated by Catherine Porter (Cambridge, MA: Harvard University Press, 1993), 22–4.

11 Georges Didi-Huberman, *Mouvements de l'air. Étienne-Jules Marey, photographes des fluides* (Paris: Gallimard, 2004), 187.

12 Ibid.

13 Norbert Wiener, *Cybernetics, or Control and Communication in the Animal and the Machine* (Cambridge, MA: MIT Press, 1962).

14 Johann Kaspar Lavater, *Essays on Physiognomy*, translated by Thomas Holcroft (London: William Tegg, 1853), 11.

15 Benjamin, 'Little History of Photography', 510.

16 Ibid., 511–12.

17 Georges Didi-Huberman, *Invention of Hysteria: Charcot and the Photographic Iconography of the Salpêtrière*, translated by Alisa Hartz (Cambridge, MA: MIT Press, 2004).

18 Ibid, 26, emphasis ours.

19 Gaston Bachelard, *The New Scientific Spirit*, translated by Arthur Goldhammer (Boston: Beacon Press, 1984), 12.

20 Ibid., 13 (translation modified).

21 Ibid.

22 Gaston Bachelard, *The Formation of the Scientific Mind*, translated by Mary McAllester Jones (Manchester: Clinamen, 2002), 240.

23 Ibid.
24 Emmanuel Levinas, *Totality and Infinity: An Essay on Exteriority*, translated by Alphonso Lingis (Pittsburgh, PA: Duquesne University Press, 1969).
25 Benjamin, 'The Work of Art in the Age of Mechanical Reproduction', 225.
26 Duchenne de Boulogne's book is divided into two parts, one 'scientific', the other 'aesthetic'. In his *Movement*, Marey also dedicates a whole chapter to the 'locomotion of man from the artistic point of view': Guillaume Duchenne de Boulogne, *Le Mécanisme de l'analyse électrophysiologique de l'expression des passions applicable à la pratique des arts plastiques* (Paris: Baillière et Renouard, 1862); Étienne-Jules Marey, *Movement*, translated by Eric Pritchard (New York: Appleton, 1895).
27 Jack Goody, *The Domestication of the Savage Mind* (Cambridge: Cambridge University Press, 1977), 84.
28 Ibid.
29 Gilles Deleuze, *Foucault*, translated by Seán Hand (Minneapolis: University of Minnesota Press, 1988), 36–7.
30 Ibid. 34.
31 Claude-Henri de Rouvroy, comte de Saint-Simon, *L'Organisateur* (1820), in *Oeuvres* (Paris: Anthropos, 10 vols, 1966), Vol. 2, 199.
32 Marey, *Movement*, 57.
33 Deleuze, *Foucault*, 82, emphasis ours.
34 Michel Foucault, *Discipline and Punish: The Birth of the Prison*, translated by Alan Sheridan (New York: Vintage Books, 1995), 218, emphasis ours.
35 Jules Amar, *Moteur humain et les bases scientifiques du travail professionnel* (Paris: Dunod et Pirat, 1914). Charles Frémont, 'Les mouvements de

l'ouvrier dans le travail professionnel', *Le Monde moderne*, no. 1 (February 1895), 187–94.

36 Bernard Stiegler, *States of Shock: Stupidity and Knowledge in the 21st Century*, translated by Daniel Ross (Cambridge: Polity, 2015), 138.

37 Louis Quéré, *Des miroirs équivoques: aux origines de la communication moderne* (Paris: Aubier-Montaigne, 1982), 54.

38 Sloterdijk, *Spheres 1: Bubbles Microspherology*, 189.

39 Karl Marx and Friedrich Engels, *The Communist Manifesto: A Modern Edition*, translated by Eric Hobsbawm (London: Verso, 2012), 38.

40 Sloterdijk, *Spheres I: Bubbles Microspherology*, 189.

41 Filippo Tommaso Marinetti, 'The Founding and Manifesto of Futurism', in Lawrence Rainey, Christine Poggi, and Laura Whitman (eds), *Futurism: An Anthology*, (New Haven, CT and London: Yale University Press, 2009), 49–53: 51. Originally published in *Le Figaro*, 20 February 1909.

42 Serge Milan, *L'Antiphilosophie du futurisme. Propagande, idéologie et concepts dans les manifestes de l'avant-garde italienne (1909–1944)* (Lausanne: L'Âge d'Homme, 2009), 31.

43 Marinetti, 'The Founding and Manifesto of Futurism', 51.

44 Gérard Granel, 'Les années 30 sont devant nous', in *Études* (Paris: Galilée, 1995), 87.

45 Catherine Malabou, *What Should We Do With Our Brain?*, translated by Sebastian Rand (New York: Fordham University Press, 2008), 28.

46 Marey, *Movement*, 183.

47 See Hans Bellmer, *Little Anatomy of the Physical Unconscious, or The Anatomy of the Image*,

translated by Jon Graham (Waterbury Center, VT: Dominion Press, 2004).

48 Jean-François Lyotard, *The Postmodern Explained: Correspondence, 1982–1985*, translated by Don Barry et al. (Minneapolis: University of Minnesota Press, 1992), 79–80.

49 Ibid., 93.

Chapter 3 The Apparelled Face

1 Philippe Ariès, *A History of Private Life: Vol. 3, Passions of the Renaissance*, translated by Arthur Goldhammer (Cambridge, MA: Belknap Press, 1993).

2 Georges Bataille, *Lascaux, or the Birth of Art*, translated by Austryn Wainhouse (Geneva: Skira, 1955), 115.

3 Bernard Lafargue, 'Des figures du visage aux visages des figures', *Figures de l'art 5: L'art des figures* (2000–1).

4 Ibid.

5 André Leroi-Gourhan, *Gesture and Speech*, translated by Anna Bostock Berger (Cambridge, MA: MIT Press, 1993), 229.

6 Sloterdijk, *Spheres I: Bubbles Microspherology*, 163–4.

7 Ibid., 164.

8 Jean-Louis Déotte, *L'Époque des appareils* (Paris: Lignes & Manifeste, 2004), 198.

9 David le Breton, *Des visages. Essai d'anthropologie* (Paris: Métailié, 1992), 170.

10 Günther Anders, 'On Promethean Shame', in Christopher John Müller, *Prometheanism: Technology, Digital Culture, and Human Obsolescence* (London and New York: Rowman & Littlefield International, 2016), 29–95. 'Promethean

shame is the refusal to owe anything, including one-self, to anyone else' (31).

11 Sloterdijk, *Spheres I: Bubbles Microspherology*, 160.
12 Pierre Chantraine, *Dictionnaire étymologique de la langue grecque* (Paris: Klincksieck, 1975).
13 Françoise Frontisi-Ducroux, *Du masque au visage. Aspects de l'identité en Grèce ancienne* (Paris: Flammarion, 1995), 17.
14 Ibid.
15 Ibid., 57.
16 Pierre Hadot, 'De Tertullien à Boèce. Le développe-ment de la notion de personne dans les controverses théologiques', in Ignace Meyerson (ed.), *Problèmes de la personne* (Paris: Éditions de l'EHESS, 1973), 123–34 : 123–4.
17 Edmond Jabès, 'Qu'est-ce qu'un livre sacré?', in Adélie and Jean-Jacques Rassial (eds), *L'Interdit de la représentation*, Colloque de Montpellier (1981) (Paris: Seuil, 1984), 11–17: 17.
18 Bernard Stiegler, 'Leroi-Gourhan: l'inorganique organisé', *Les Cahiers de médiologie* 6 (1998), https://www.cairn.info/article.php?ID_ARTICLE=CDM_006_0187.
19 Ibid.
20 Bernard Stiegler, *Technics and Time 1: The Fault of Epimetheus*, translated by Richard Beardsworth and George Collins (Stanford, CA: Stanford University Press, 1998), 193.
21 Ibid., 152–3.
22 Jacques Derrida, *On Grammatology*, translated by Gayatri Chakravorty Spivak (Baltimore, MD: Johns Hopkins University Press, 1997), 145.
23 Georg Simmel, 'The Aesthetic Significance of the Face', translated by Lore Ferguson, in Kurt H. Wolff

(ed.), *Georg Simmel, 1858–1919* (Columbus, OH: Ohio State University Press, 1959), 276–81: 276.

24 Ignace Meyerson, 'Préface', in Meyerson (ed.), *Problèmes de la personne*, 7–10: 9.

25 Marcel Mauss, 'A Category of the Human Mind: The Notion of Person; the Notion of Self' [1938], translated by W. D. Halls, in Michael Carrithers, Steven Collins, and Steven Lukes (eds), *The Category of the Person: Anthropology, Philosophy, History* (Cambridge: Cambridge University Press, 1985), 1–25. Note that in 1945, Mauss would go on to supervise Leroi-Gourhan's doctorate.

26 Jean-Pierre Vernant, 'The Individual in the City-State', in Jean-Pierre Vernant, *Mortals and Immortals: Collected Essays* (Princeton: Princeton University Press, 1991), 318–35: 327.

27 Françoise Frontisi-Ducroux and Jean-Pierre Vernant, *Dans l'oeil du miroir* (Paris: Odile Jacob, 1997), 243.

28 Ibid., emphasis ours.

29 Frontisi-Ducroux states: '[T]he open presence of the mirror indicates that woman must see, before being seen.' The mirror conditions the gaze that she casts upon herself, she is the object of the gaze for man (ibid., 246).

30 Ibid., 103.

31 Sloterdijk, *Spheres I: Bubbles Microspherology*, 34.

32 Frontisi-Ducroux, *Du masque au visage*, 102.

33 Ibid., 362.

34 Mauss, 'A Category of the Human Mind', 8–9.

35 Ibid., 19.

36 Giorgio Agamben, *Nudities*, translated by David Kishik and Stefan Pedatella (Stanford, CA: Stanford University Press, 2010), 50.

37 Sloterdijk, *Spheres I: Bubbles Microspherology*, 203.
38 Ibid., 197.
39 Claude Cahun, *Disavowals or Cancelled Confessions*, translated by Susan de Muth (London: Tate Publishing, 2007), 183.
40 François Leperlier, *Claude Cahun. L'écart et la métamorphose* (Paris: Jean-Michel Place, 1992). Translated by Liz Heron as *Claude Cahun: Masks and Metamorphoses* (London: Verso, 1997).
41 Following Foucault's studies on the history of sexuality, the Hellenist and queer theorist David Halperin wrote *One Hundred Years of Homosexuality and Other Essays on Greek Love* (London and New York: Routledge, 1990).
42 Joan Rivière, 'Womanliness as a Masquerade', in Victor Burgin, James Donald, and Cora Kaplan (eds), *Formations of Fantasy* (London: Methuen, 1986), 35–44; Judith Butler, *Gender Trouble: Feminism and the Subversion of Identity* (London and New York: Routledge, 1990).
43 Tristan Garcia, *Form and Object: A Treatise on Things*, translated by Mark Allan Ohm and Jon Cogburn (Edinburgh: Edinburgh University Press, 2014), 239.
44 Arthur Danto, 'Past Masters and Post Moderns: Cindy Sherman's History Portraits', in *Cindy Sherman: History Portraits: The Rebirth of the Painting after the End of Painting* (Munich and Paris: Shirmer/Mosel, 2012), 9–13: 12.
45 Déotte, *L'Époque des appareils*, 100.
46 Alain Badiou, *The Century*, translated by Alberto Toscano (Cambridge: Polity, 2007), chapter 5.
47 François Chaignaud, Nariné Karslyan, and Lalla

Kowska-Regnier, 'Are You for Real?', *Terrain Vague* 1 (July 2015).

48 Gilles Deleuze, *Difference and Repetition*, translated by Paul Patton (New York: Columbia University Press, 1994), 293.

49 Stiegler, 'Différance and Repetition: Thinking Différance as Individuation', chapter 3 of *States of Shock*, 62–85: 67.

50 Deleuze, *Difference and Repetition*, 19.

51 Ibid., 287.

52 Ibid., xx.

53 Ibid., 18.

54 Sylvie Patry and Quentin Bajac (eds), *Correspondances 23. Valérie Belin/Édouard Manet* (Paris: Argol/Musée d'Orsay, 2008), 24.

55 Ibid.

56 Kimiko Yoshida, *Marry Me! Les mariées intangibles. Autoportraits* (Arles: Actes Sud, 2003), 6.

57 Badiou, *The Century*, 56.

58 Christine Buci-Glucksmann, *La Folie du voir. Une esthétique du virtuel* (Paris: Galilée, 2002), 266. [This passage does not appear in the English edition: Christine Buci-Glucksmann, *The Madness of Vision: On Baroque Aesthetics*, translated by Dorothy Z. Baker (Athens: Ohio University Press, 2013). – Translator's note]

59 Marshall McLuhan, *Understanding Media: The Extensions of Man* (Cambridge, MA, and London: MIT Press, 1994), 41.

60 Ibid.

61 See Laurent de Sutter, *Narcocapitalism: Life in the Age of Anaesthesia*, translated by Barnaby Norman (Cambridge: Polity, 2018), for an updated version of this thesis.

62 Marshall McLuhan, 'Myth and Mass Media', *Daedalus* 88.2 (1959), 339–48.
63 McLuhan, *Understanding Media*, 43.
64 Ibid., 46.
65 Ibid., 6.
66 Ibid., 46.

Chapter 4 The Space of Appearances
 1 Hannah Arendt, *The Human Condition* (Chicago and London: University of Chicago Press, 1998), 198.
 2 Ibid., 198–9.
 3 Hannah Arendt, *The Promise of Politics* (New York: Schocken, 2005), 95.
 4 Déotte, *L'Époque des appareils*, 190.
 5 Michel Foucault, *The Order of Things: An Archaeology of the Human Sciences* (London and New York: Routledge, 1989), 384.
 6 Emmanuel Levinas, *Existence and Existents*, translated by Alphonso Lingis (The Hague: Martinus Nijhoff, 1978), 94.
 7 Benjamin, 'The Work of Art in the Age of Mechanical Reproduction', 251.
 8 Jean-Luc Nancy, *Being Singular Plural*, translated by Robert D. Richardson and Anne E. O'Byrne (Stanford, CA: Stanford University Press, 2000), 67.
 9 Ibid., 61.
10 Déotte, *L'Époque des appareils*, 198.
11 Frédéric Neyrat, *Surexposés. Le monde, le capital, la Terre* (Paris: Léo Scheer, 2005), 118.
12 Olivier Ertzscheid, 'L'homme est un document comme les autres: du World Wide Web au World Life Web', *Cognition, communication, politique* 2009, 33–40, https://archivesic.ccsd.cnrs.fr/sic0037 7457v1/document.

13 Gilles Deleuze, 'Postscript on Control Societies', in *Negotiations: 1972–1990*, translated by Martin Joughin (New York: Columbia University Press, 1995), 169–82.

14 Boris Groys, *Going Public (e-flux journal)* (Berlin: Sternberg Press, 2010), 25.

15 Emanuele Coccia, *Goods: Advertising, Urban Space, and the Moral Law of the Image*, translated by Marissa Gemma (New York: Fordham University Press, 2018; eBook), 'The Last Name of the Good'.

16 Ibid.

17 Ibid., chapter 1.

18 Ibid.

19 Laurent de Sutter, *Métaphysique de la putain* (Paris: Léo Scheer, 2014), 19.

20 Ibid.

21 Siegfried Kracauer, *The Mass Ornament: Weimar Essays*, translated by Thomas Y. Levin (Cambridge, MA, and London: Harvard University Press, 1995).

22 [The phrase appears in a letter from Kracauer to Theodor Adorno of 27 August 1955 (A&K 633), cited in Dagmar Barnouw, *Critical Realism: History, Photography, and the Work of Siegfried Kracauer* (Baltimore, MD: Johns Hopkins University Press, 1994), 157, 353n. 43. – Translator's note]

23 Kracauer, *The Mass Ornament*, 79.

24 Nancy, *Being Singular Plural*, 63.

25 Kracauer, *The Mass Ornament*, 79.

26 Ibid., 81.

27 Nick Srnicek and Alex Williams, '#Accelerate: Manifesto for an Accelerationist Politics', in Armen Avanessian and Robin Mackay (eds), *#Accelerate: The Accelerationist Reader* (London and Berlin: Urbanomic/Merve, 2014), 347–62.

28 Kracauer, *The Mass Ornament*, 86.

29 Ibid., 83.
30 Ibid.
31 Christine Buci-Glucksmann, *Philosophie de l'ornement. D'Orient en Occident* (Paris: Galilée, 2008), 156.
32 Kracauer, *The Mass Ornament*, 326, emphasis ours.
33 Buci-Glucksmann, *Philosophie de l'ornement*, 157.
34 Antonio Negri, 'Approximations Towards an Ontological Definition of the Multitude', translated by Arianna Bove, *Multitudes* 9 (May–June, 2002), 36–48, http://www.generation-online.org/t/approximations.htm.
35 Coccia, *Goods*, chapter 3.
36 Nancy, *Being Singular Plural*, 134.
37 Ibid., 138.
38 Emanuele Coccia, *Sensible Life: A Micro-ontology of the Image*, translated by Scott Alan Stuart (New York : Fordham University Press, 2016), 37.
39 Daniel Bougnoux, 'Faire visage, comme on dit faire surface', *Cahiers de médiologie* 1, no. 15, 'Faire Face' (2008), https://www.cairn.info/revue-les-cahiers-de-mediologie-2003-1-page-9.htm.

Chapter 5 Critique of the Political Economy of Faces

1 Jeremy Rifkin, *The Age of Access: The New Culture of Hypercapitalism* (New York: Jeremy P. Tarcher/Putman, 2000), 198.
2 Yann Moulier-Boutang, *Cognitive Capitalism*, translated by Ed Emery (Cambridge: Polity, 2011).
3 Olivier Ertzscheid, 'L'axe de rotation du web a changé !', Affordance.info, 1 September 2013, https://affordance.typepad.com/mon_weblog/2013/09/laxe-de-rotation-du-web-a-change-.html.
4 Félix Guattari, *The Machinic Unconscious*, translated

by Taylor Adkins (Los Angeles: Semiotext(e), 2011), 79.

5 André Gorz, 'Économie de la connaissance, exploitation des savoirs. Entretien réalisé par Yann Moulier-Boutang et Carlo Vercellone', *Multitude* 15 (2004), 'La créativité au travail'.

6 Luc Boltanski and Eve Chiapello, *The New Spirit of Capitalism*, second edition, translated by Gregory Elliott (London: Verso, 2018), 76.

7 Pierre Bourdieu et al., *Photography: A Middle-brow Art*, translated by Shaun Whiteside (Cambridge: Polity, 1990).

8 Groupe Marcuse, *De la misère humaine en milieu publicitaire* (Paris: La Découverte, 2004), 87.

9 Colton Valentine, 'Richard Prince Sold Strangers' Instagram Photos For $90k – And It's Probably Legal', *Huffington Post*, 30 June 2015; Jessica Contrera, 'A Reminder That Your Instagram Photos Aren't Really Yours: Someone Else Can Sell Them for $90,000', *The Washington Post*, 25 May 2015; Imane Moustakir, 'Un artiste américain vend vos photos Instagram pour 90 000 dollars pièce', *Courrier international*, 27 May 2015.

10 Daniel Bougnoux, 'L'économie médiatique de l'attention: l'ivrogne et le réverbère', in Yves Citton (ed.), *L'Économie de l'attention. Nouvel horizon du capitalisme?* (Paris: La Découverte, 2014), 73–83.

11 Michael H. Goldhaber, 'Some Attention Apothegms', 15 August 1996, https://people.well.com/user/mgoldh/apoth.html.

12 See Jacques Rancière, *The Politics of Aesthetics: The Distribution of the Sensible*, translated by Gabriel Rockhill (London and New York: Continuum, 2004).

13 Yves Citton, *Pour une écologie de l'attention* (Paris: Seuil, 2014), 218.

14 Rancière, *The Politics of Aesthetics*, 38.

15 Louise Merzeau, 'De la face au profil: l'aventure numérique des visages', *Ina Global* 4 (2015), 156–63.

16 Dominique Cardon, 'Dans l'esprit du PageRank. Une enquête sur l'algorithme de Google', *Réseaux* 1, no. 177 (2013), 63–95, emphasis ours.

17 Jean-Claude Kaufmann, 'Tout dire de soi, tout montrer', *Le Débat* 3, no. 125 (2003), 145.

18 Before the end of his presidential term, Barack Obama decided to reduce Manning's sentence, which was judged to be too severe, to seven years' imprisonment. She was released on 17 May 2017 and was able to attend the exhibition.

19 https://www.fridmangallery.com/a-becoming-resemblance.

20 Antoinette Rouvroy, 'Face à la gouvernementalité algorithmique, repenser le sujet de droit comme puissance' (2012), https://works.bepress.com/antoinette_rouvroy/43/ .

21 Louise Merzeau, 'Du signe à la trace: l'information sur mesure', *Hermès* 53, no. 1 (2009), 23–30.

22 Louise Merzeau, 'La médiation identitaire', *Revue française des sciences de l'information et de la communication* 1 (2012), https://journals.openedition.org/rfsic/193.

23 Agamben, *Nudities*, 50.

24 Guattari, *The Machinic Unconscious*, 76.

25 Ibid.

Chapter 6 In the Flow

1 Bertrand Vergely, 'Dans la lumière d'un regard', in *Le Visage. Dans la clarté, le secret demeure* (Paris: Autrement, 1994), 99.

2 Gilles Deleuze and Félix Guattari, *A Thousand Plateaus*, translated by Brian Massumi (Minneapolis: University of Minnesota Press, 1987), 171.

3 Christine Buci-Glucksmann, 'La disparition du visage en art', *Revue des sciences humaines* 243 (1996), 'Faire visage', ed. Philippe Bonnefis, Dolorès Djidzek-Lyotard, and Patrick Wald Lasowski, 131.

4 André Gunthert, 'Que dit la théorie de la photographie?', *Études photographiques* 34 (2016), https://journals.openedition.org/etudesphotographiques/3588.

5 Fredric Jameson, *Postmodernism, or the Cultural Logic of Late Capitalism* (Durham, NC: Duke University Press, 1991), 11.

6 Ibid.

7 Ibid., 15.

8 François De Smet, *Lost Ego. La tragédie du 'je suis'* (Paris: PUF, 2017), 12.

9 Ibid., 17.

10 Érik Bordeleau, *Foucault anonymat* (Montréal: Le Quartanier, 2012), 19.

11 Marc Augé, *Non-Places: Introduction to an Anthropology of Supermodernity*, translated by John Howe (London and New York: Verso, 1995), 120.

12 Anne Cauquelin, *Le Site et le Paysage* (Paris: PUF, 2002), 35.

13 Michel de Certeau, *The Practice of Everyday Life*, translated by Steven Rendall (Berkeley: University of California Press, 1984).

14 Julien Verhaeghe, *Art & Flux. Une esthétique du contemporain* (Paris: L'Harmattan, 2014), 17. See also Julien Verhaeghe and Marion Zilio, 'Devenirmonde. Un archivage cartographique de la quotidienneté',

Réel-virtuel 2 (March 2011), 'Virtualité et quotidienneté', 1–9.

15 Boris Groys, 'Modernity and Contemporaneity: Mechanical vs Digital Reproduction', in *In the Flow* (London and New York: Verso, 2016), 137–56.

16 Benjamin, 'The Work of Art in the Age of Mechanical Production', 220.

17 Carole Rivière, 'Mobile Camera Phones: A New Form of "Being Together" in Daily Interpersonal Communication', in Rich Ling and Per E. Pedersen (eds), *Mobile Communications: Re-negotiation of the Social Sphere* (London: Springer-Verlag, 2005), 167–86 : 174.

18 Coccia, *Goods*, chapter 3.

19 Ibid., chapter 5

20 Ibid.

21 Jean-Samuel Beuscart, Dominique Cardon, Nicolas Pissard, and Christophe Prieur, 'Pourquoi partager mes photos de vacances avec des inconnus? Les usages de Flickr', *Réseaux* 2, no. 154 (2009), 91–129.

22 A 'pervasive environment' (or ubiquitous environment) corresponds to a global functioning of communication where a diffuse informatics allows communicating objects to interact with one another.

23 Yoshida, *Marry Me!*, 6.

24 Deleuze, *Foucault*, 82.

25 Liu Bolin, 'Quand le camouflage devient stratégie', in *Liu Bolin* (Paris: Galerie Paris–Beijing, 2013), 19.

26 Deleuze and Guattari, *A Thousand Plateaus*, 200.

27 Hanna Rose Shell, *Hide and Seek: Camouflage, Photography, and the Media of Reconnaissance* (New York: Zone Books, 2012), 25.

28 Ibid., 14.

29 Garcia, *Form and Object*, 238.
30 Shell, *Hide and Seek*, 159.
31 Bruno Nassim Aboudrar, *Comment le voile est devenu musulman* (Paris: Flammarion, 2014).
32 David Le Breton, *Disparaître de soi: une tentation contemporaine* (Paris: Métailié, 2015).
33 See Roger Caillois, 'Mimicry and Legendary Psychasthenia', translated by John Shepley, *October* 31 (Winter 1984), 16–32.
34 Recall that the Greek word *prosôpon* has many meanings, designating not only the 'face', the 'mask', but also the 'façade' of a building, as set out by Pierre Chantraine in the *Dictionnaire étymologique de la langue grecque*.
35 François Dagognet, *Faces, surfaces, interfaces* (Paris: Vrin, 1982); Didier Anzieux, *Le Moi-peau* (Paris: Dunod, 1985).
36 Antoinette Rouvroy, 'Gouverner hors les normes: la gouvernementalité algorithmique', *Lacan Quotidien* 733 (July 2017).
37 Ibid.
38 Coccia, *Goods*, chapter 4.
39 Pascal Chabot, *Global Burnout*, translated by Aliza Krafetz (London: Bloomsbury, 2018; eBook), part II.
40 Latour, *We Have Never Been Modern*, 137.
41 Gilbert Simondon, *On the Mode of Existence of Technical Objects*, translated by Cecile Malaspina and John Rogove (Minneapolis: Univocal, 2017), 16.
42 Ibid.
43 Latour, *We Have Never Been Modern*.
44 Eduardo Kohn, *How Forests Think: Toward an Anthropology Beyond the Human* (Berkeley and Los Angeles: University of California Press, 2013), 9

45 Eduardo Viveiros de Castro, *Cannibal Metaphysics*, translated by Peter Skafish (Minneapolis: Univocal, 2014).

46 Kohn, *How Forests Think*, 6.

47 Eduardo Viveiros de Castro, 'Perspectivism and Multinaturalism in Indigenous America', in Alexandre Surrallés and Pedro García Hierro (eds), *The Land Within: Indigenous Territory and the Perception of Environment* (Copenhagen: IWGIA, 2004), 36–74: 38.

48 Simondon, *On the Mode of Existence of Technical Objects*, 253.

49 Sigmund Freud, 'Analysis of a Phobia of a Five-Year-Old Boy', in *The Standard Edition of the Complete Psychological Works of Sigmund Freud*, Vol. 10 (London: Hogarth Press, 1955), 5–149: 122.

50 Ibid., 57.

51 Leroi-Gourhan, *Gesture and Speech*, 407.

52 Déborah Danowski and Eduardo Viveiros de Castro, *The Ends of the World*, translated by Rodrigo Nunes (Cambridge: Polity, 2017), 70.

53 Gilbert Simondon, *Imagination et invention* (Paris: Éditions de la Transparence, 2008), 12.

Index

Index

Index

Index

Index

Index

Index

Index

Index

Index

Index

Williams, Alex 81
Wollen, Audrey 100
women
 in Ancient Greece 46–7
 treatment of hysteria in 18,
 88

writing, development of
 22–3

Yoshida, Kimiko 61–2, 63,
 110, 121
YouTube 73, 75, 92